Coloring
Metal Sculptures:

The Magical Works of Ricardo Breceda

By Diana Lindsay

Sunbelt Publications, Inc.
San Diego, California

Coloring Metal Sculptures: The Magical Works of Ricardo Breceda

Sunbelt Publications, Inc.
Copyright © 2018 by Diana Lindsay
All rights reserved. First edition 2018

Cover and book design by Kristina Filley
Project management by Deborah Young

Printed in United States of America

No part of this book may be reproduced in any form without permission from the publisher.

Please direct comments and inquiries to:

Sunbelt Publications, Inc.
P.O. Box 191126
San Diego, CA 92159-1126
(619) 258-4911, fax: (619) 258-4916
www.sunbeltpublications.com

20 19 18 17 4 3 2 1

ISBN: 978-1-941384-34-3

Front Cover: The giant serpent dragon is the best known of all of the Borrego Valley sculptures. It is certainly the most stunning as it seen diving under the road with its rattlesnake tail high in the air. It is pure fantasy waiting for the creative touch of the artist to add a splash of color. Photo by Diana Lindsay

Back Cover: Metal sculptures of extinct horses are found along Borrego Springs Road in the southern part of Borrego Valley. Horses evolved in North America about 57 million years ago. There were several successful emigrations to the Old World. They became extinct in North American about 11,000 years ago and were later reintroduced to North Amercan by the Spaniards. Seven different species of horse have been identified in Anza-Borrego's fossil record. The metal sculptures depict extinct horse in poses as they might have appeared during the Pleistocene. Photo by Paul R. Johnson

All photographs are by the author unless noted.

A Coloring Book Introduction:

Ricardo Breceda is an accidental artist. He never intended to make metal sculptures. When an accident prevented him from returning to construction work, he began selling western boots, which he sometimes traded for things, like a welding machine. When Breceda's 5-year-old daughter asked her father to make her a life-size dinosaur for Christmas, Breceda accepted the challenge and began his career as a metal sculpture artist. He had always been interested in natural history and especially animals. He had grown up on a ranch where he had close contact with many different animals. He also has the unique ability to visualize animals in 3-D in his head and move around them to see their confirmation. Transferring this ability into a metal form became his passion.

When Breceda built his first dinosaur, he was renting a home that fronted on I-215 in Perris, California. His growing collection of dinosaurs, horses, and elephants were visible to passing drivers who sometimes exited the freeway to drive to Breceda's yard to get a closer look. A few small businesses bought some of the creations to attract attention to their own potential buyers.

One day Dennis Avery, millionaire and son of the founder of Avery self-stick labels, stopped by and asked Breceda if he could build anything. When Breceda affirmed that he could, Avery commissioned him to build replicas of prehistoric animals that once roamed the Anza-Borrego desert. These fascinating creatures are described in detail in the book *Fossil Treasures of the Anza-Borrego Desert: The Last Seven Million Years*, which Avery helped to fund. It was Avery's intention to surprise and delight visitors with a vision of what the area looked like millions of years ago.

However, Avery did not stop there. He also commissioned Breceda to build dinosaurs, historical characters, modern-day animals, a jeep, and even a 300-foot-long dragon-serpent with a rattlesnake tail. In all, there are 131 metal sculptures to be encountered in Borrego Valley on properties of the Avery estate. So delighted was the community of Borrego Springs that they made Breceda Grand Marshal at one of their annual festive desert parades. Breceda made a special stagecoach that he entered in that parade lineup.

Several published works and ongoing publicity have added to the artist's notoriety that have led to great interest in his creations. Today his works are found in private yards, parks, public places, and business areas largely concentrated in southern California, although he gets orders for his works from throughout the United States and internationally. His shop is now in rural Aguanga, California, where he displays both large and small creations.

Wherever you go to visit the many locations where Breceda's sculptures may be found, you are sure to find at least a few of the 40 iconic sculptures in this coloring book to remind you of the days you went out exploring and discovered the magical works of Ricardo Breceda.

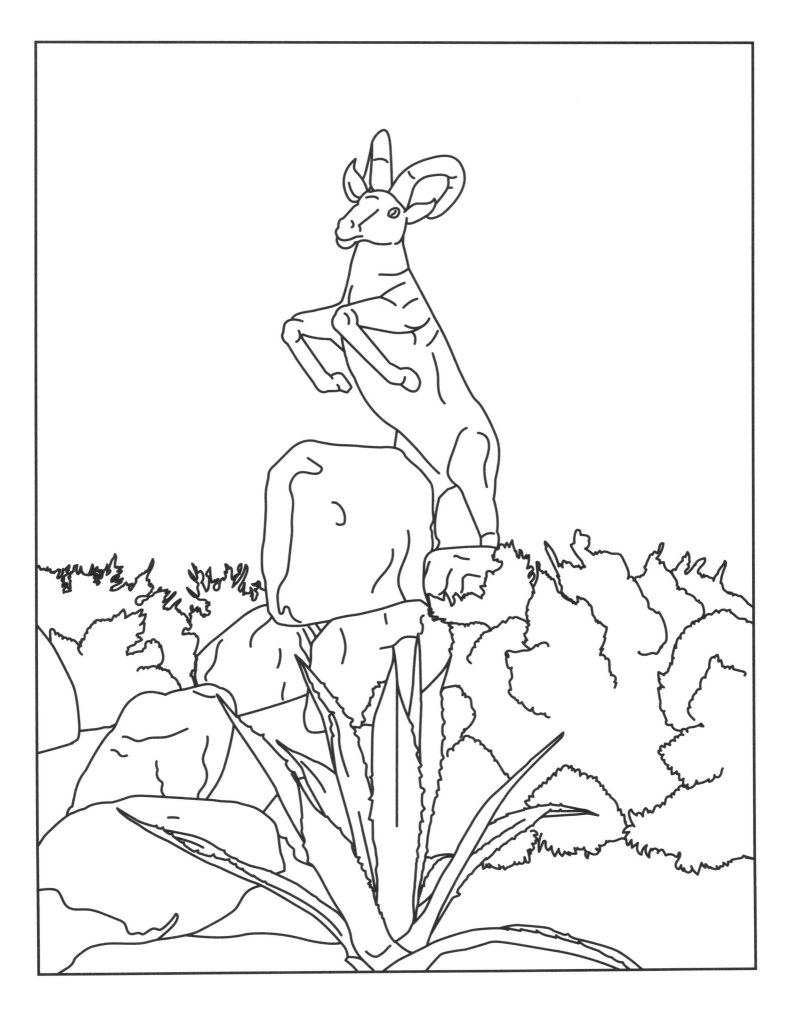

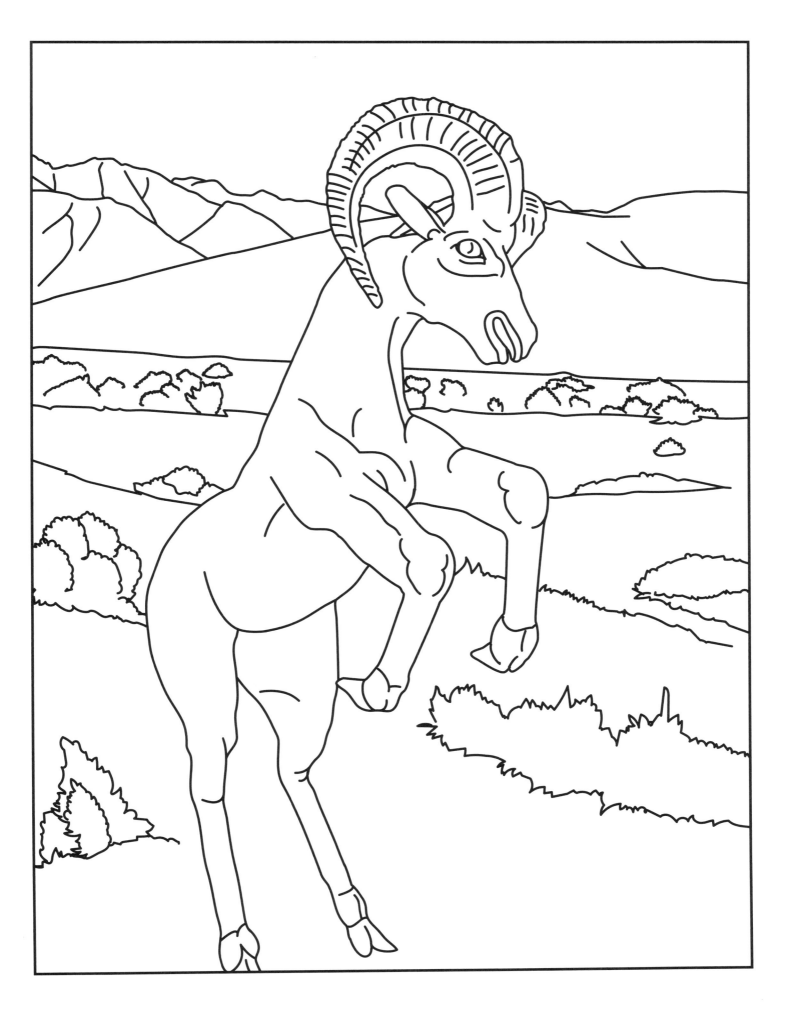

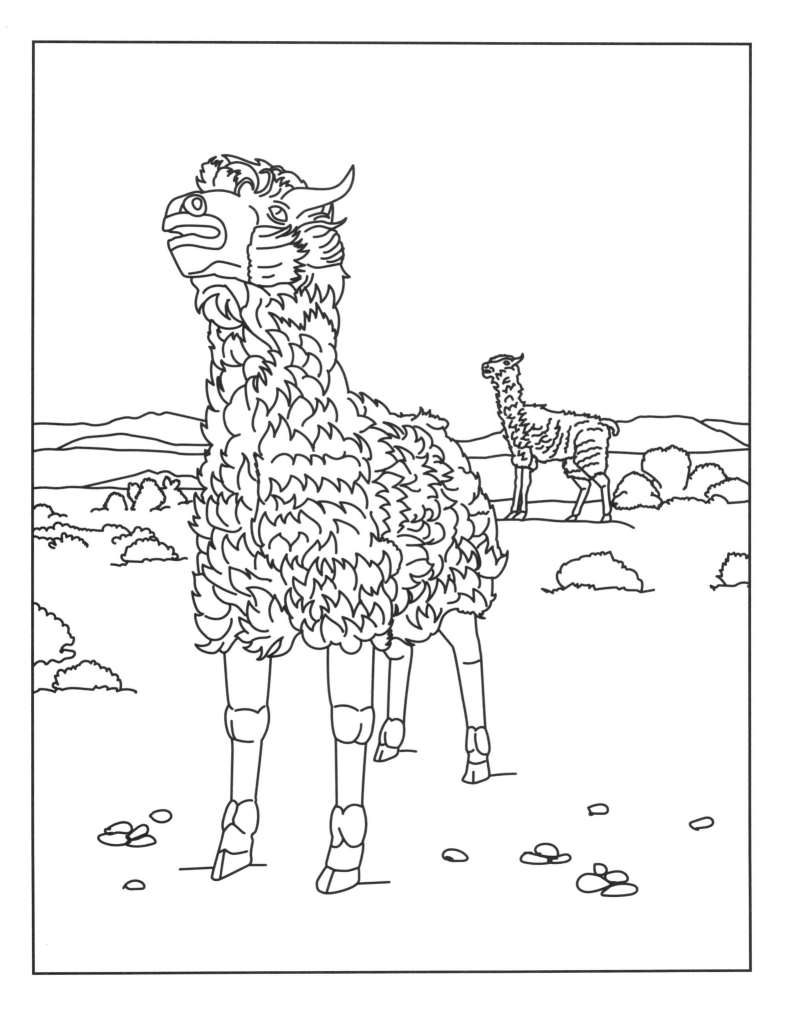

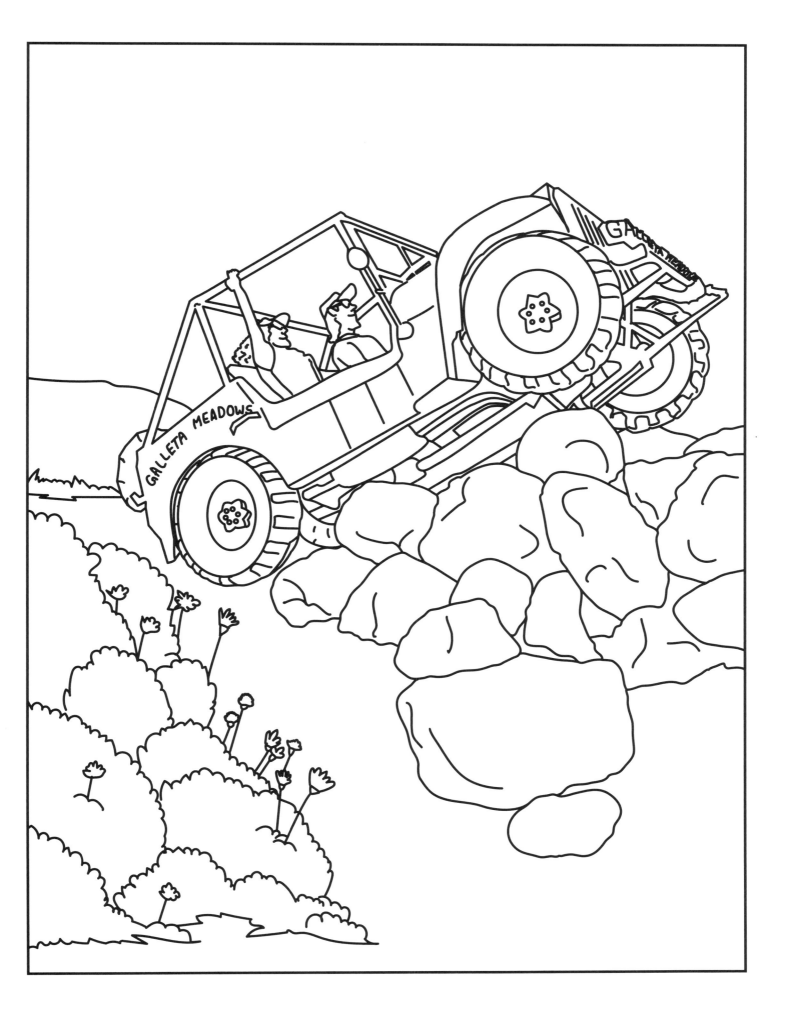

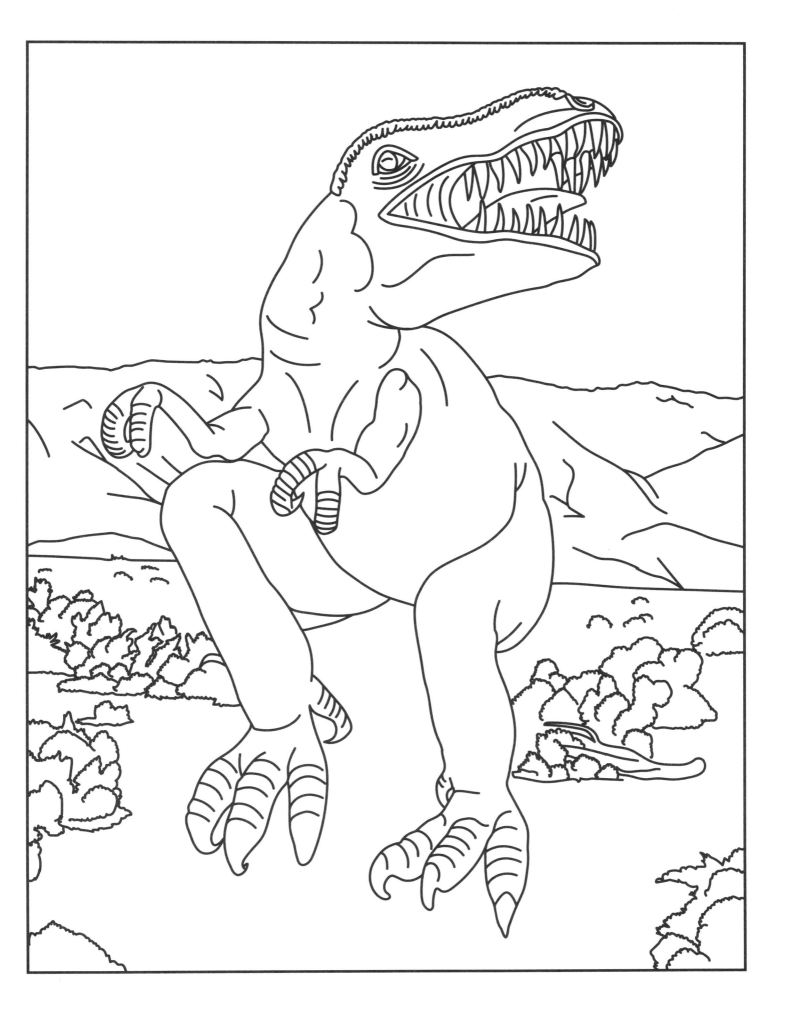

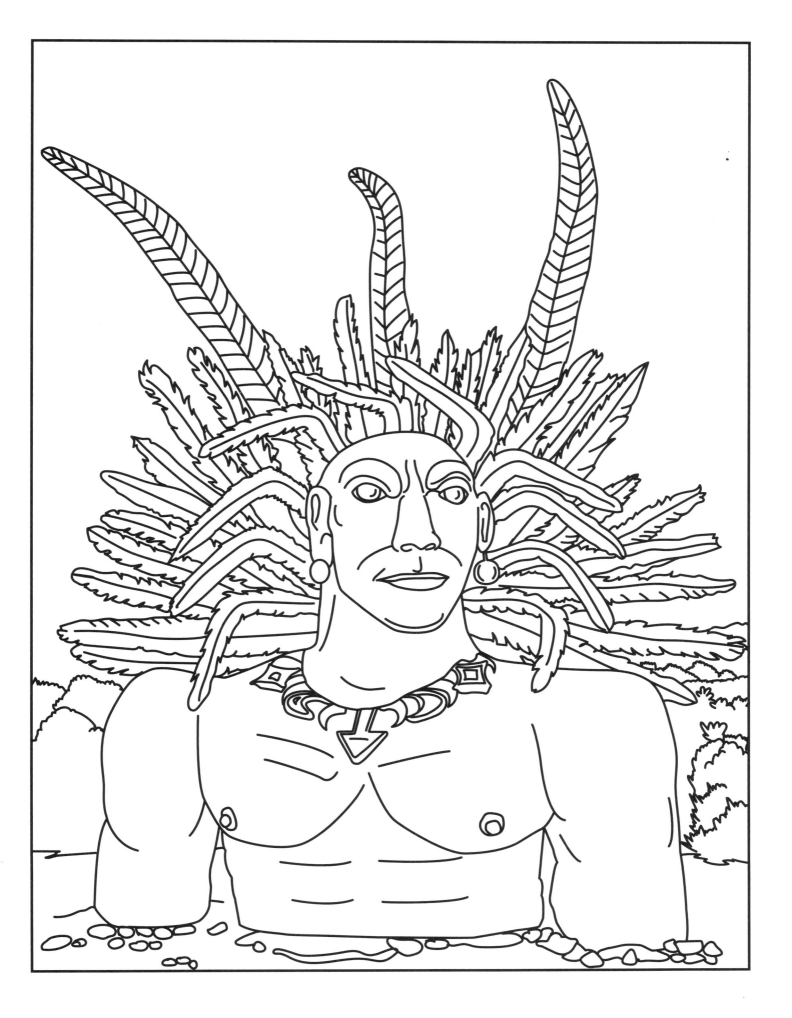

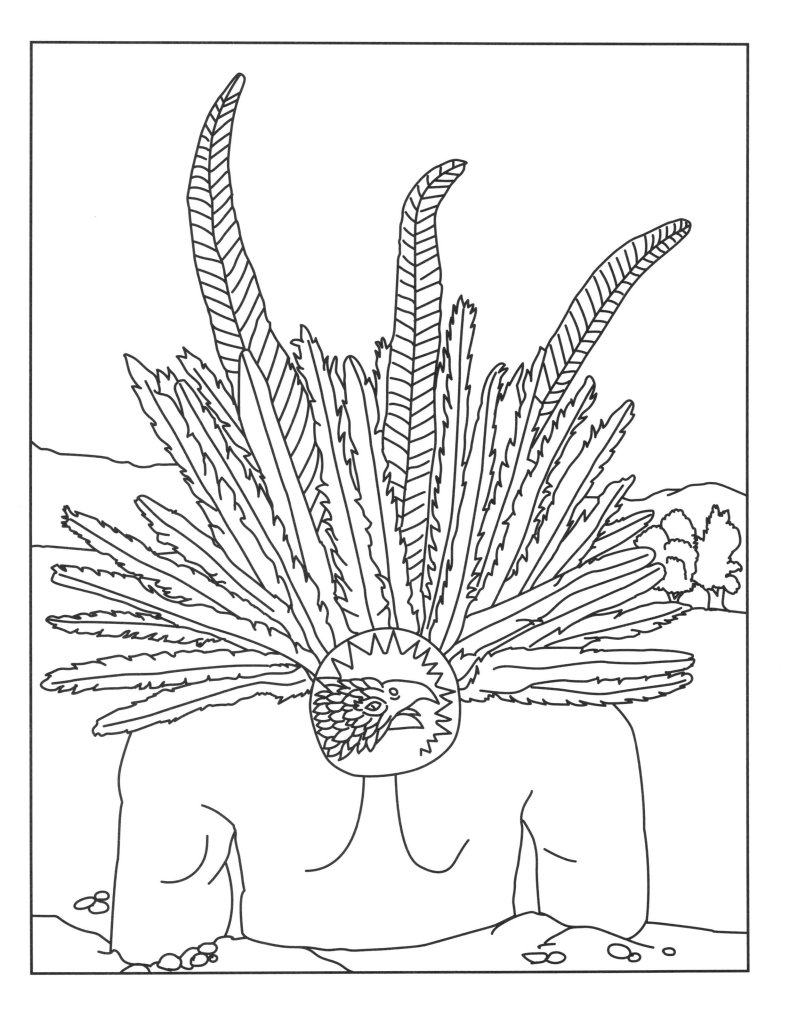

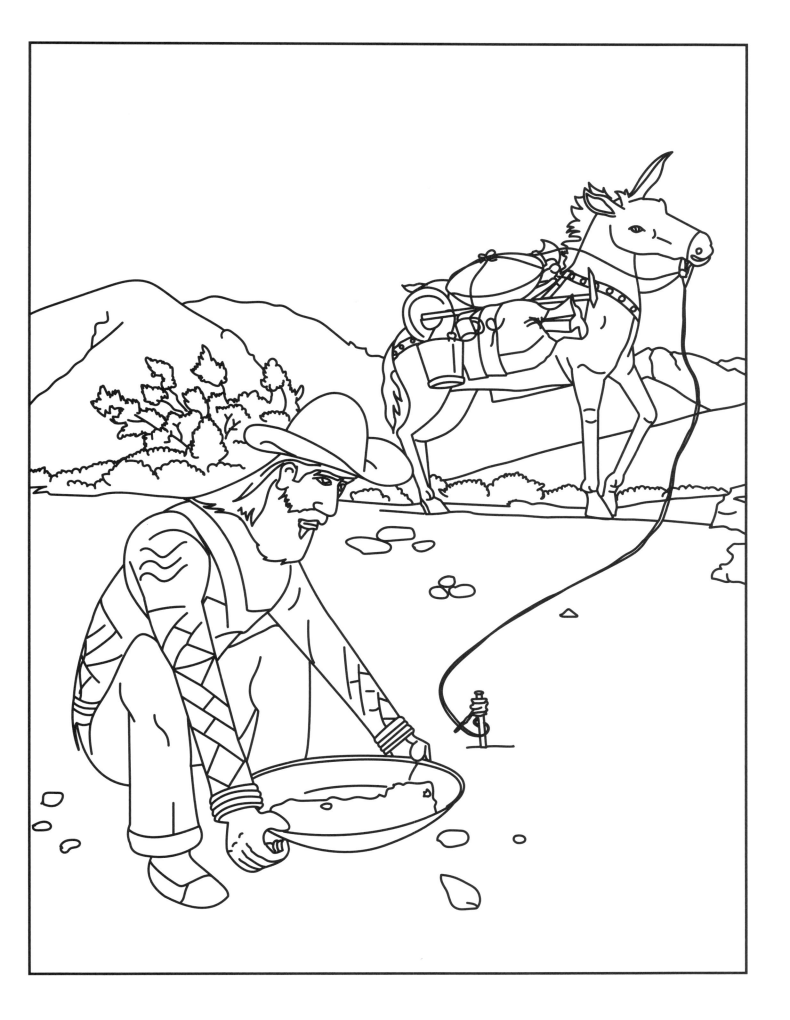

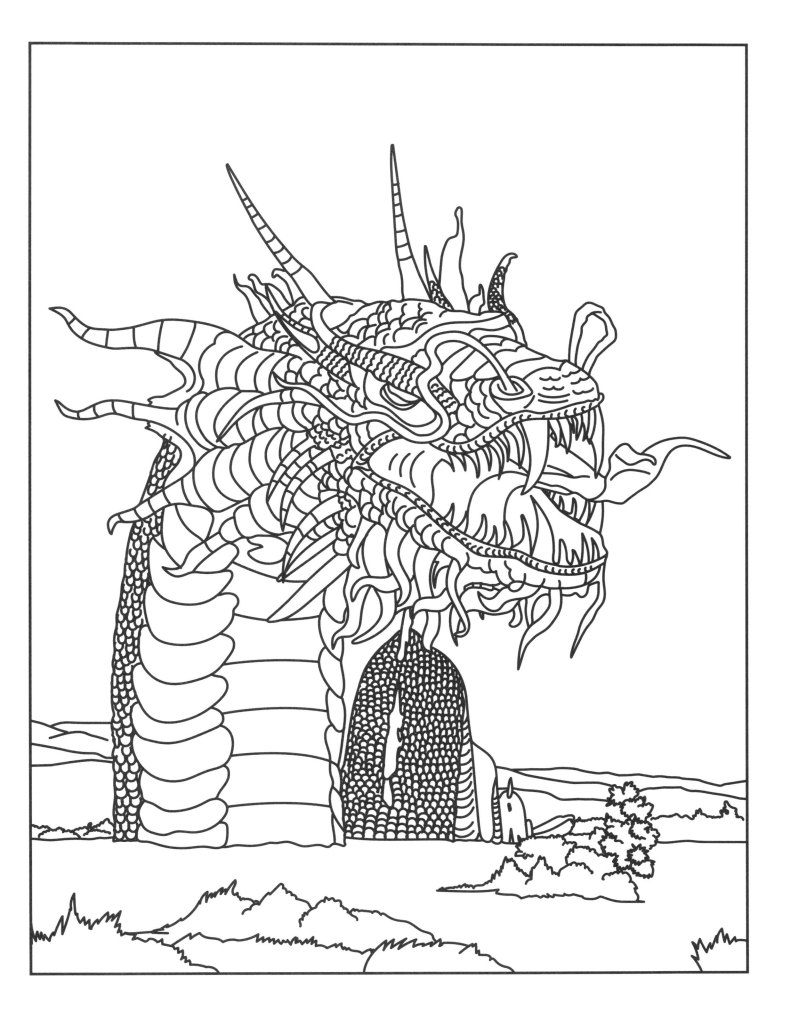

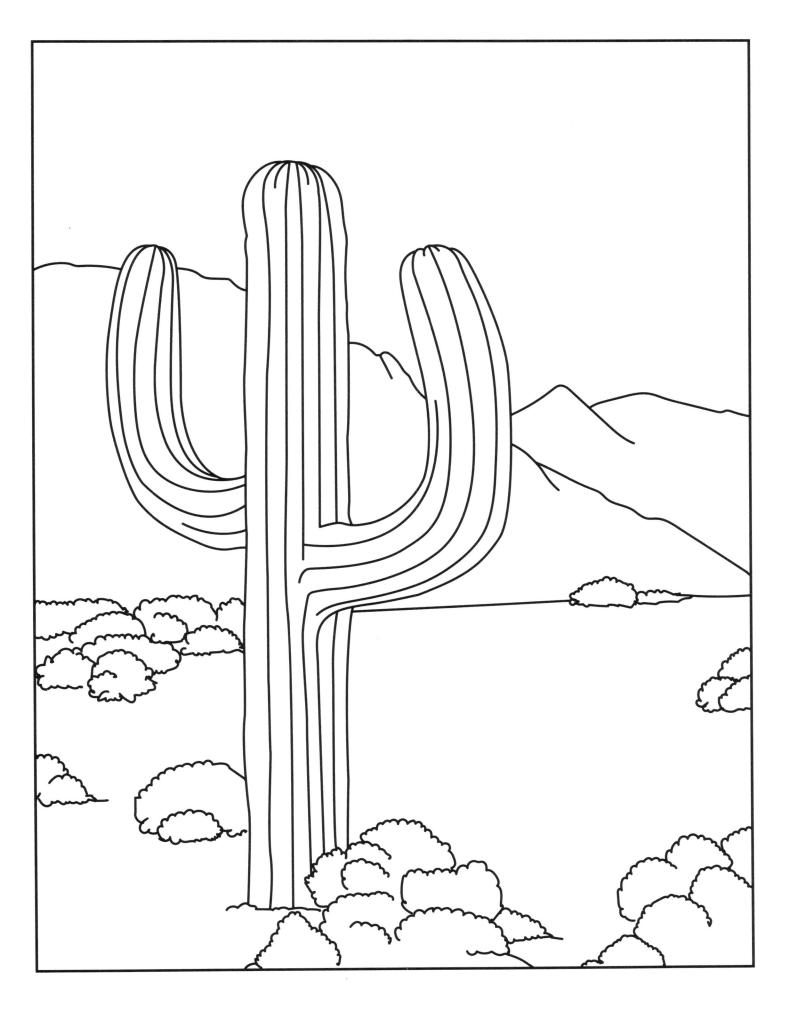

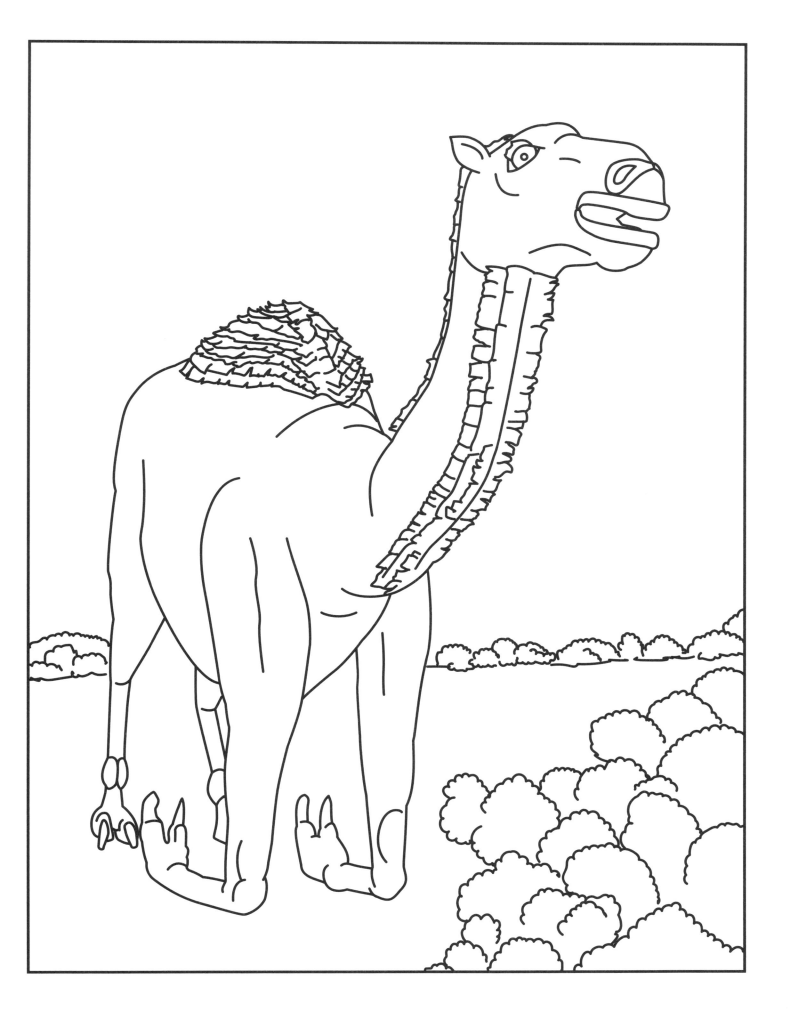

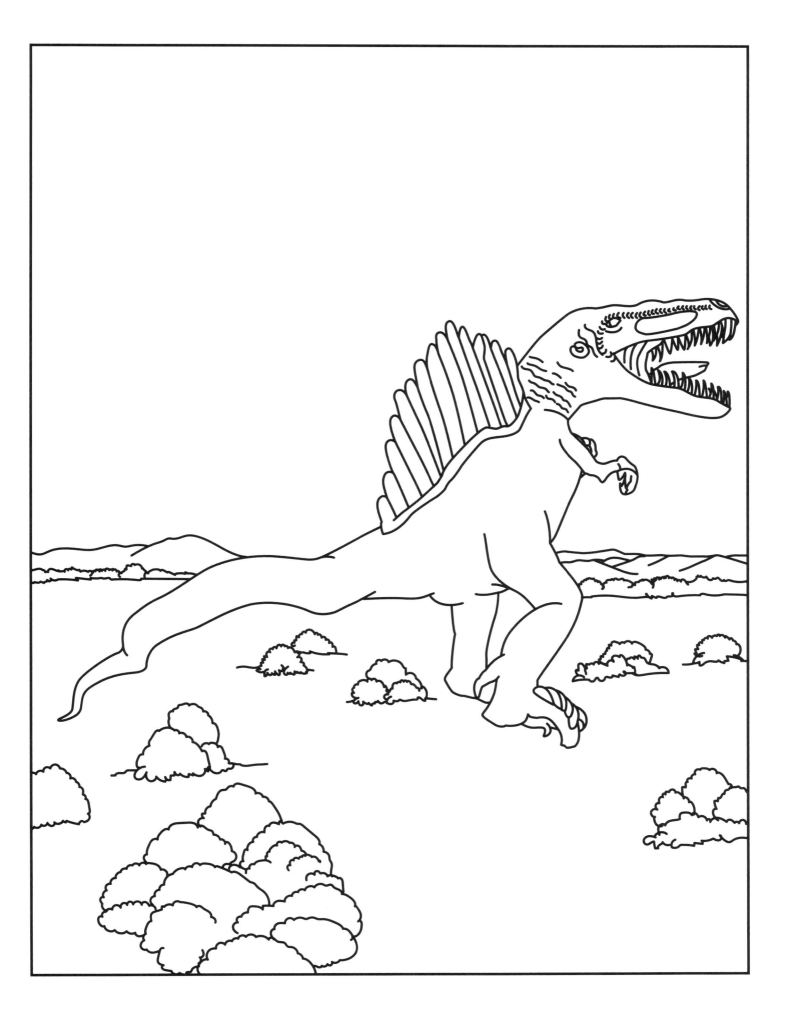

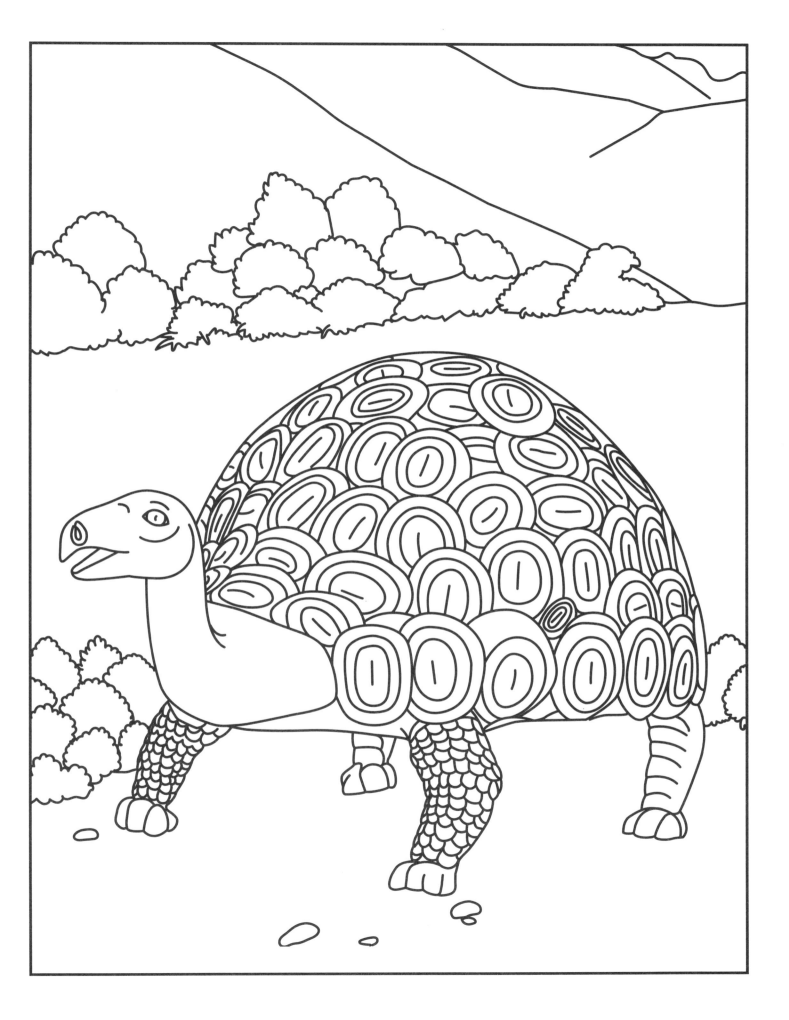

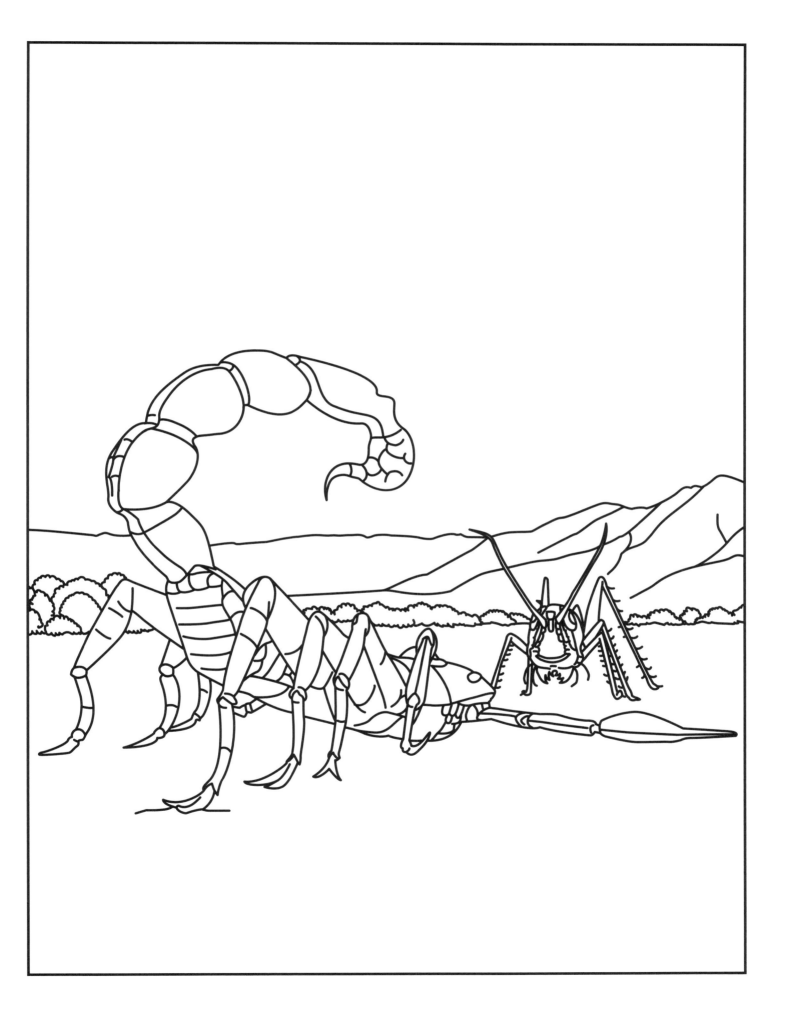

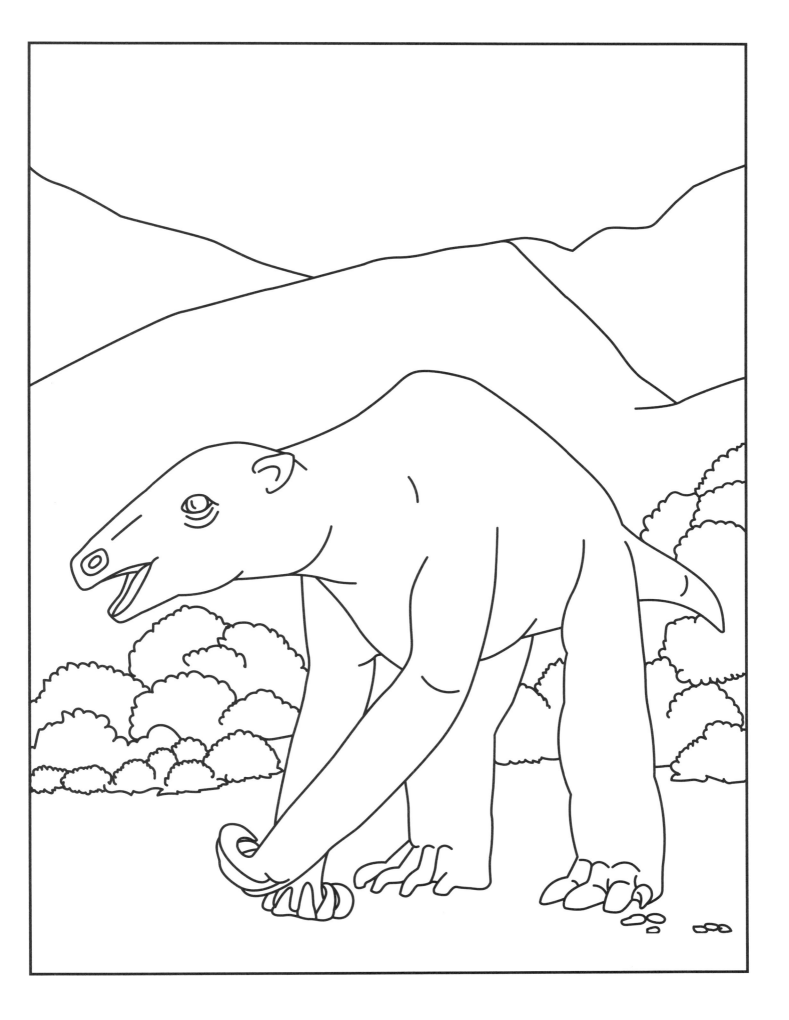

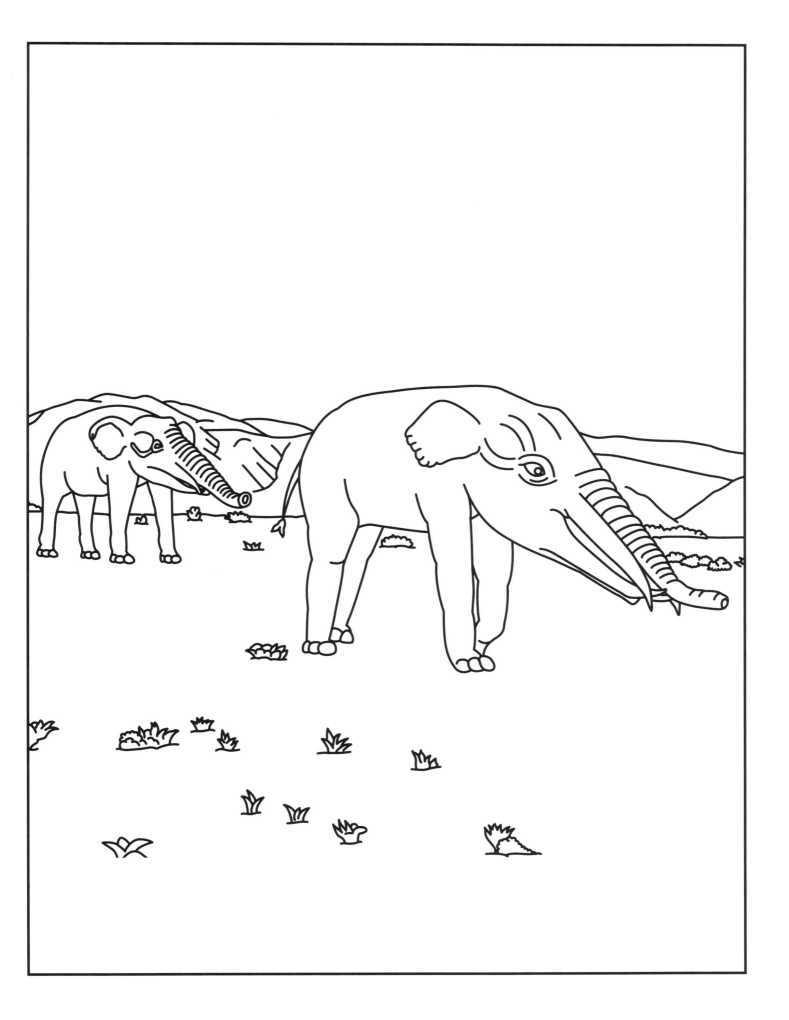

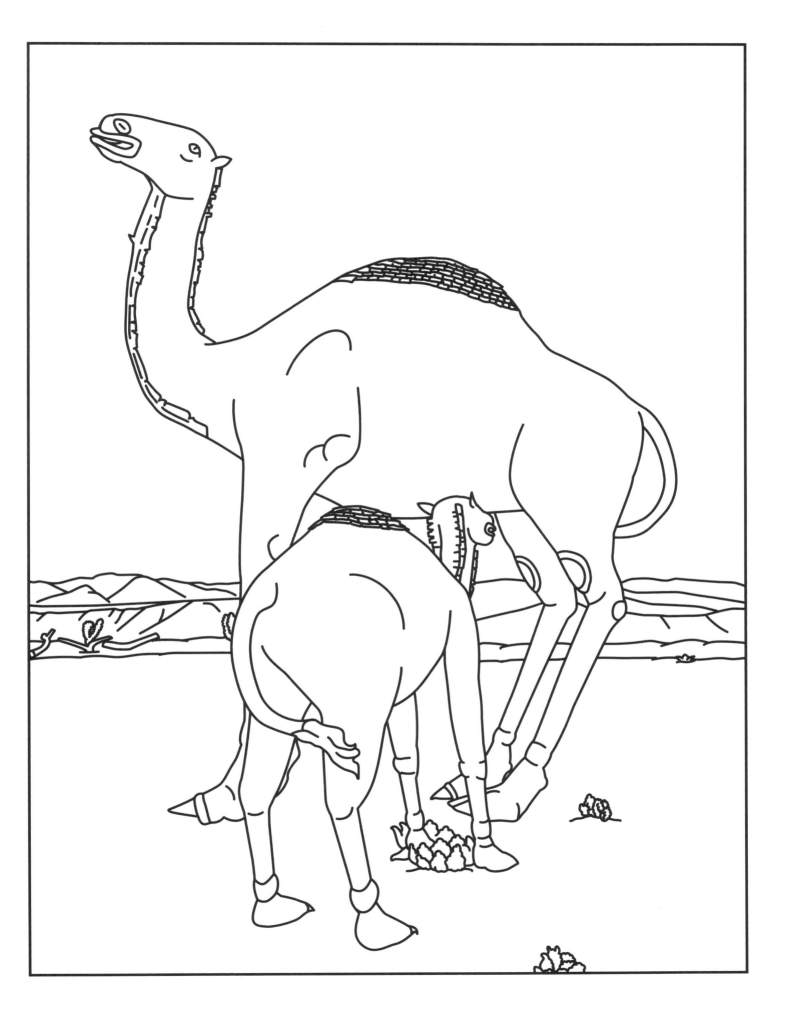

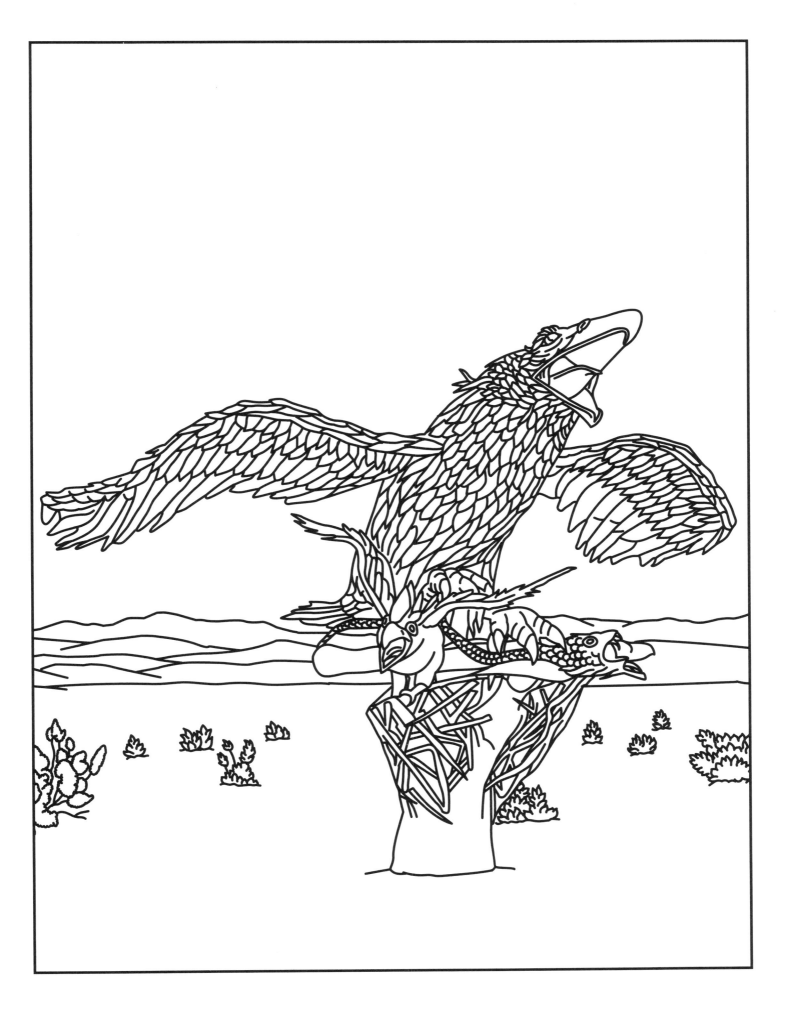

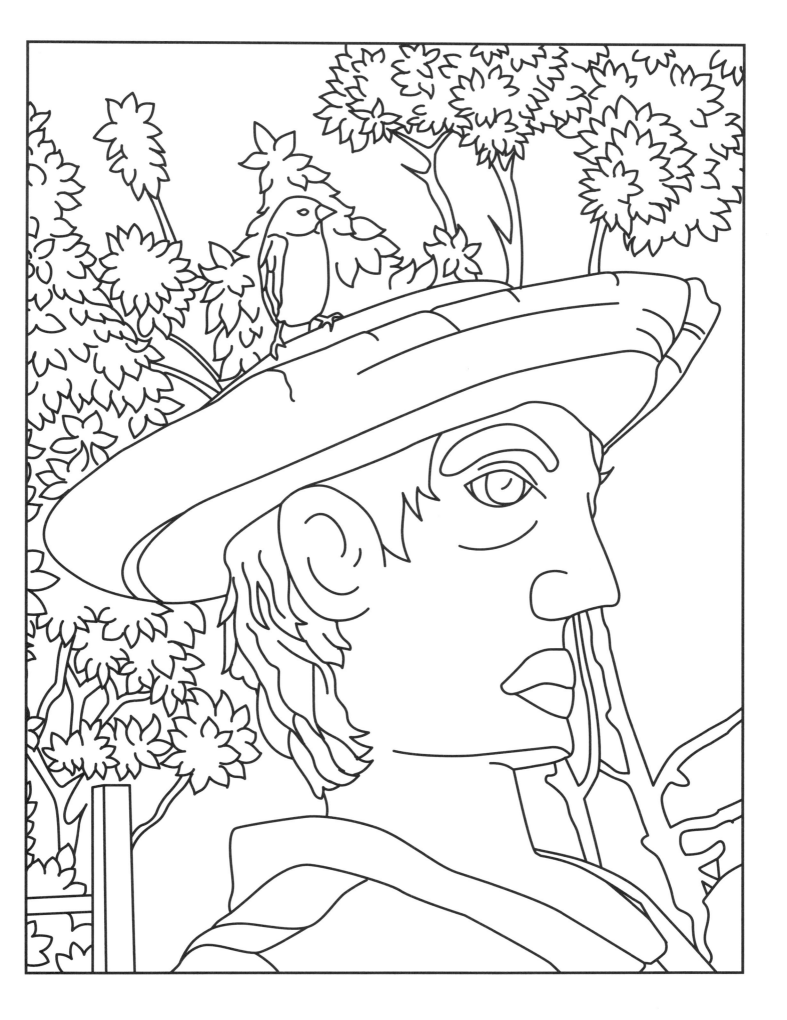

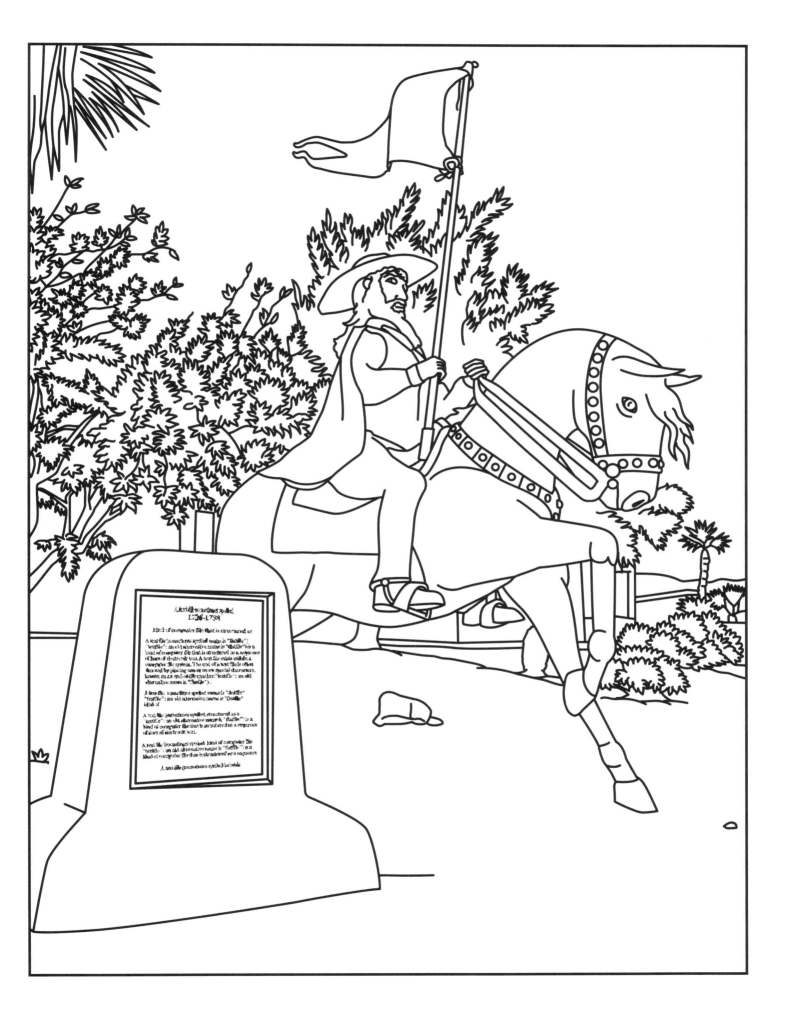

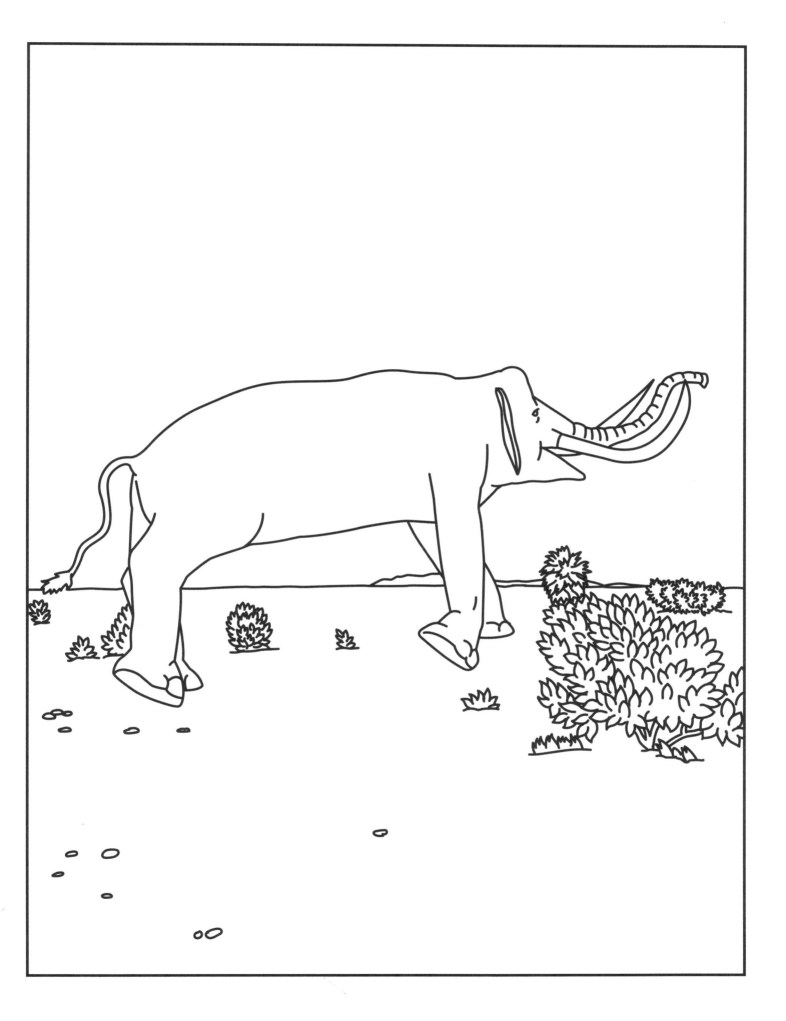

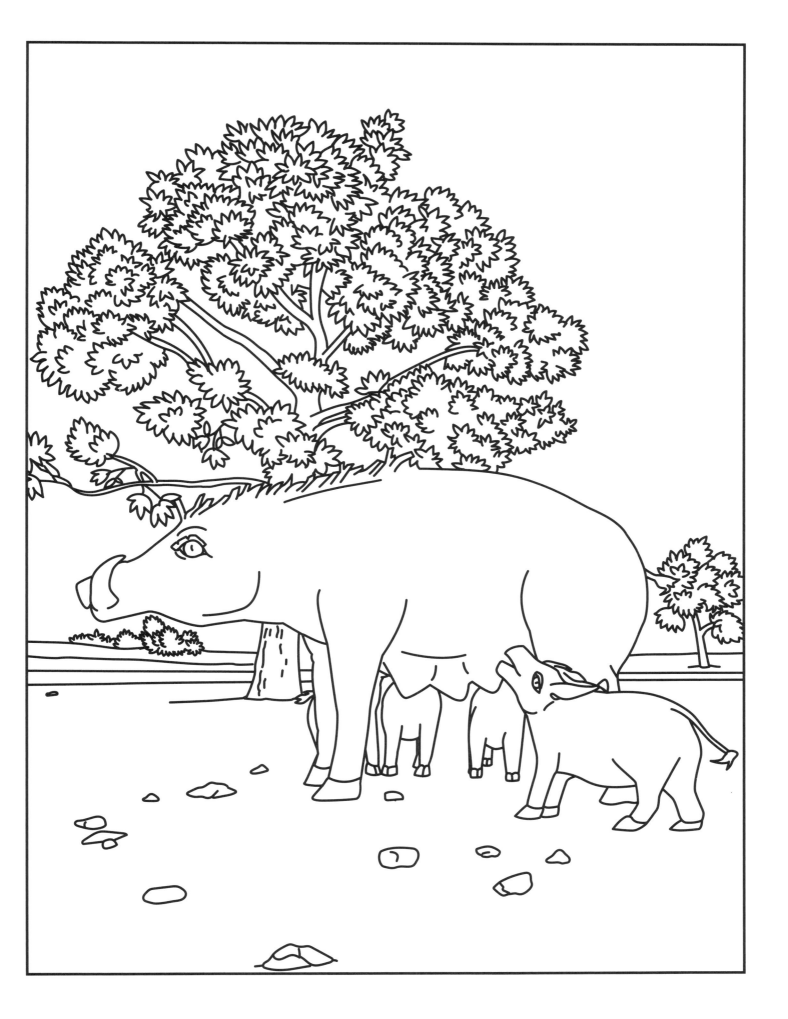

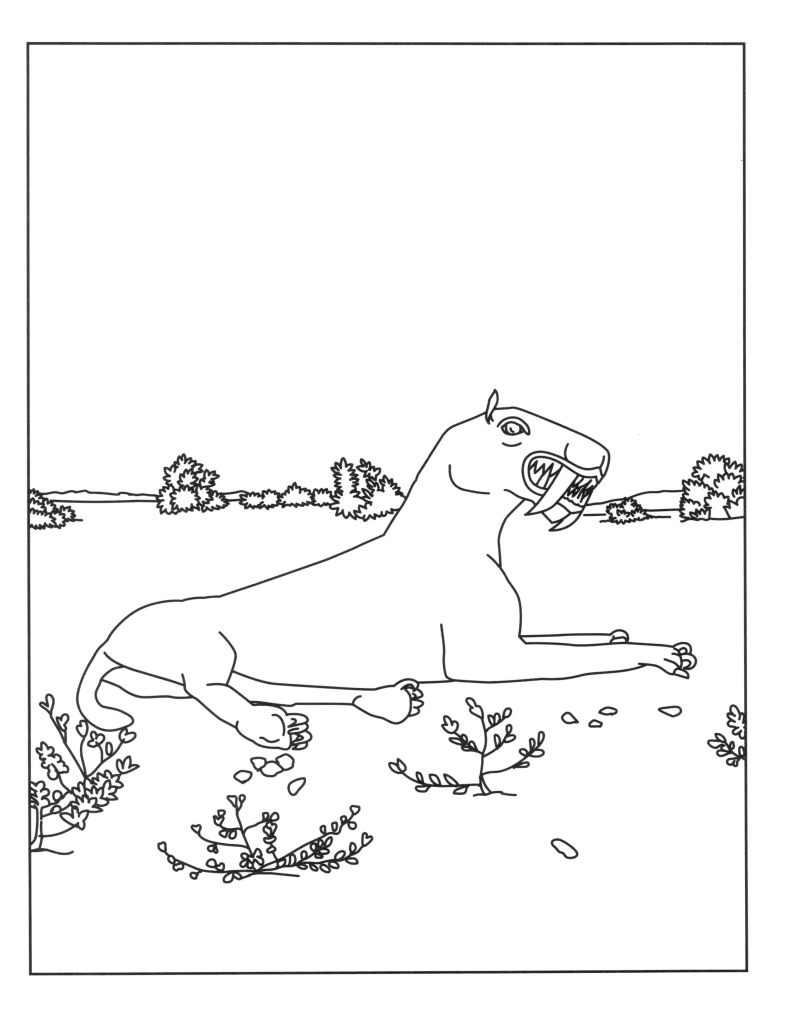

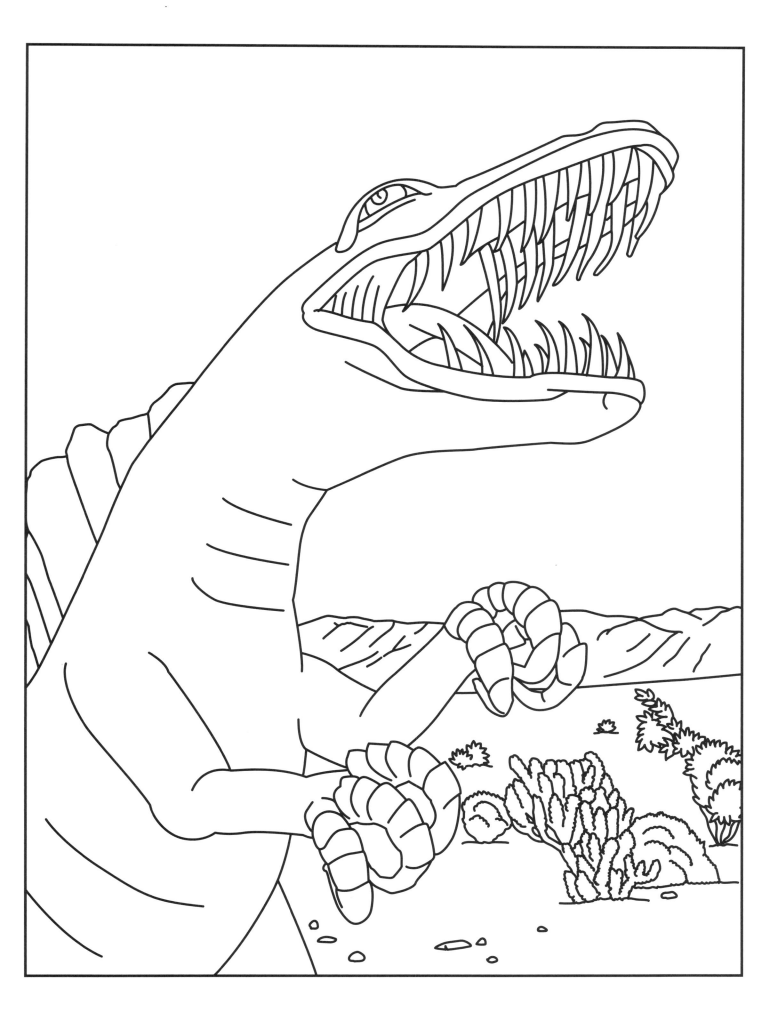

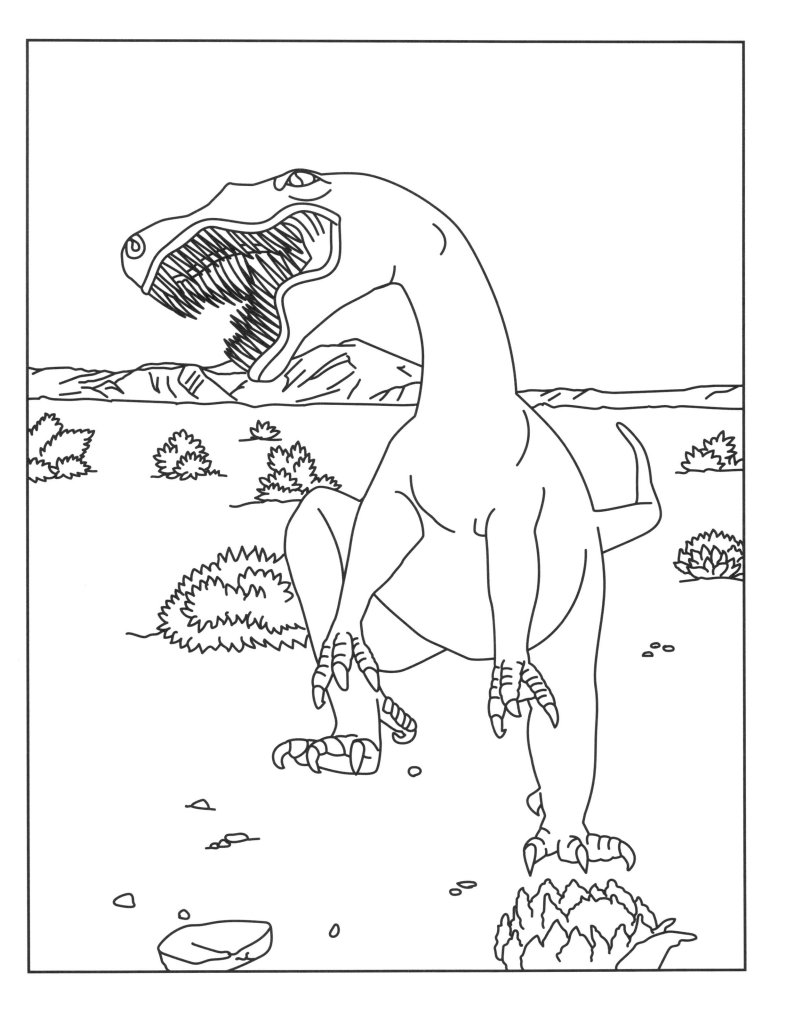

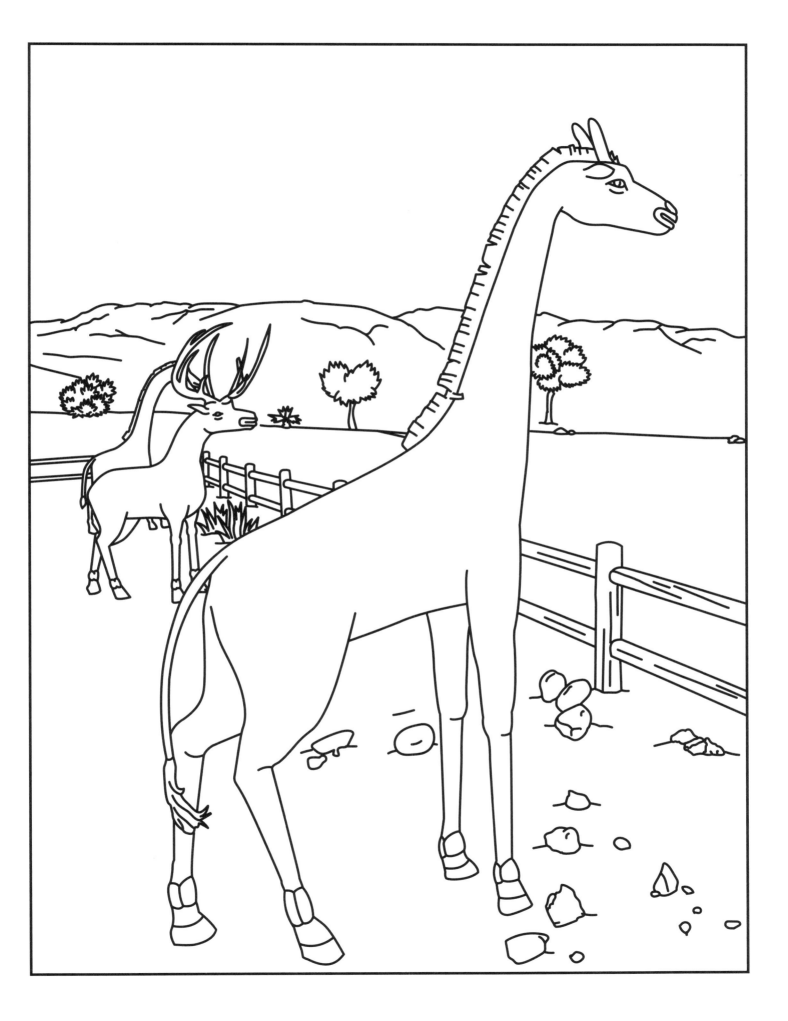

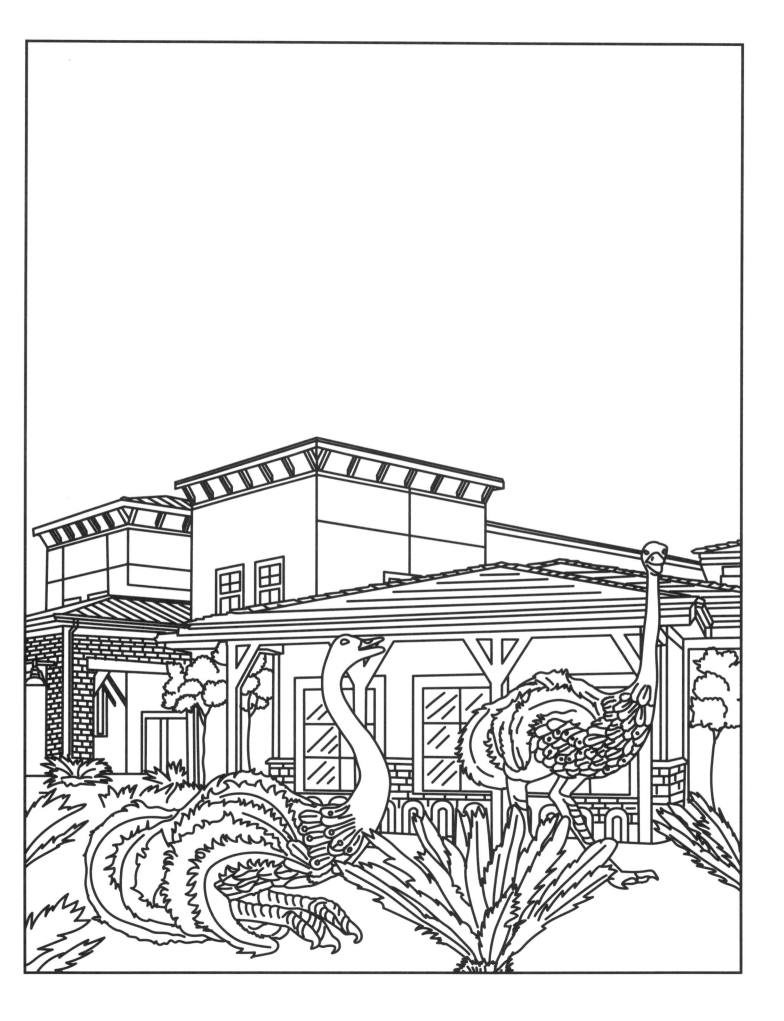

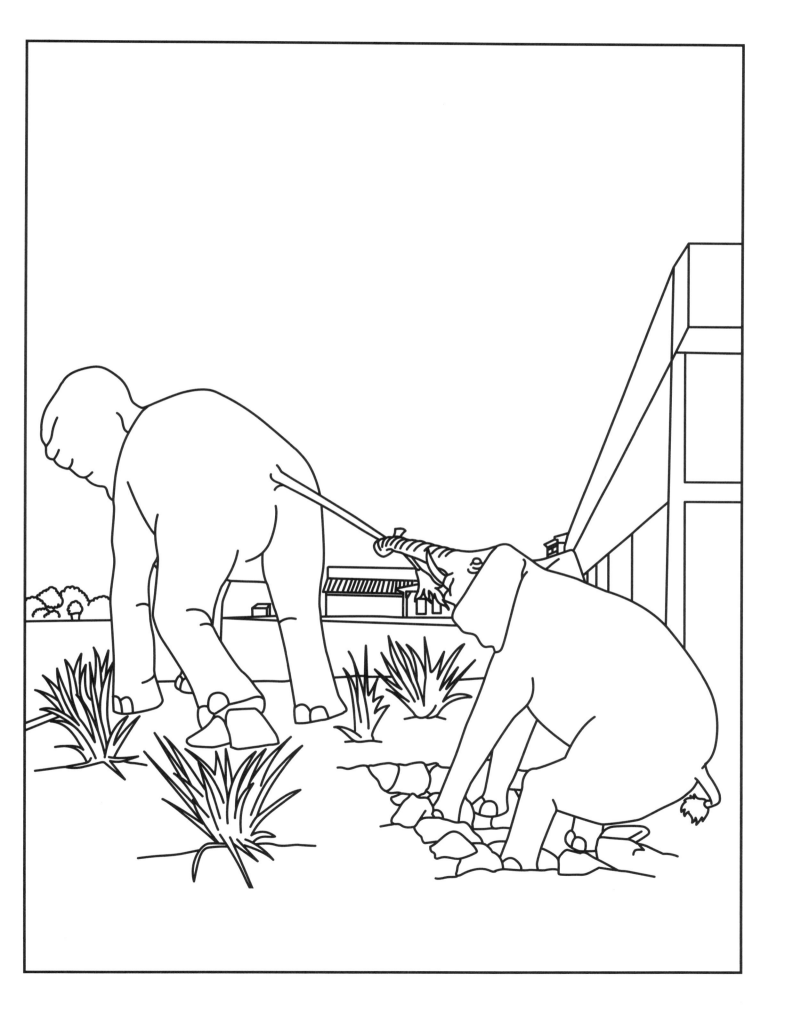

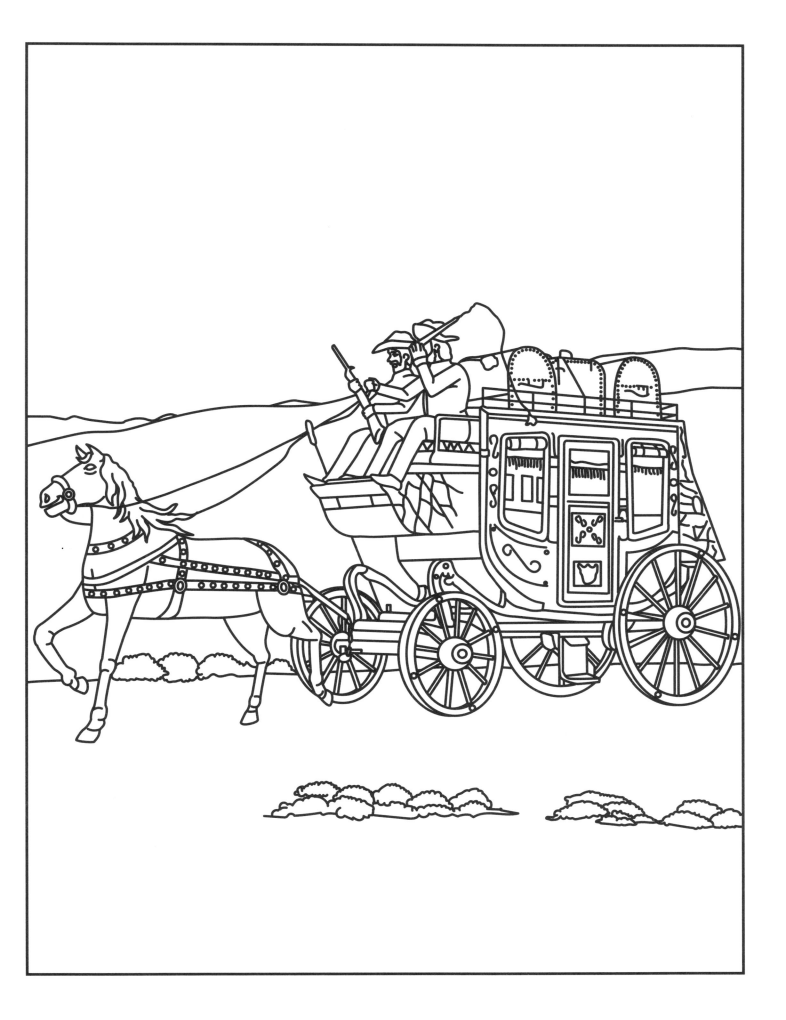

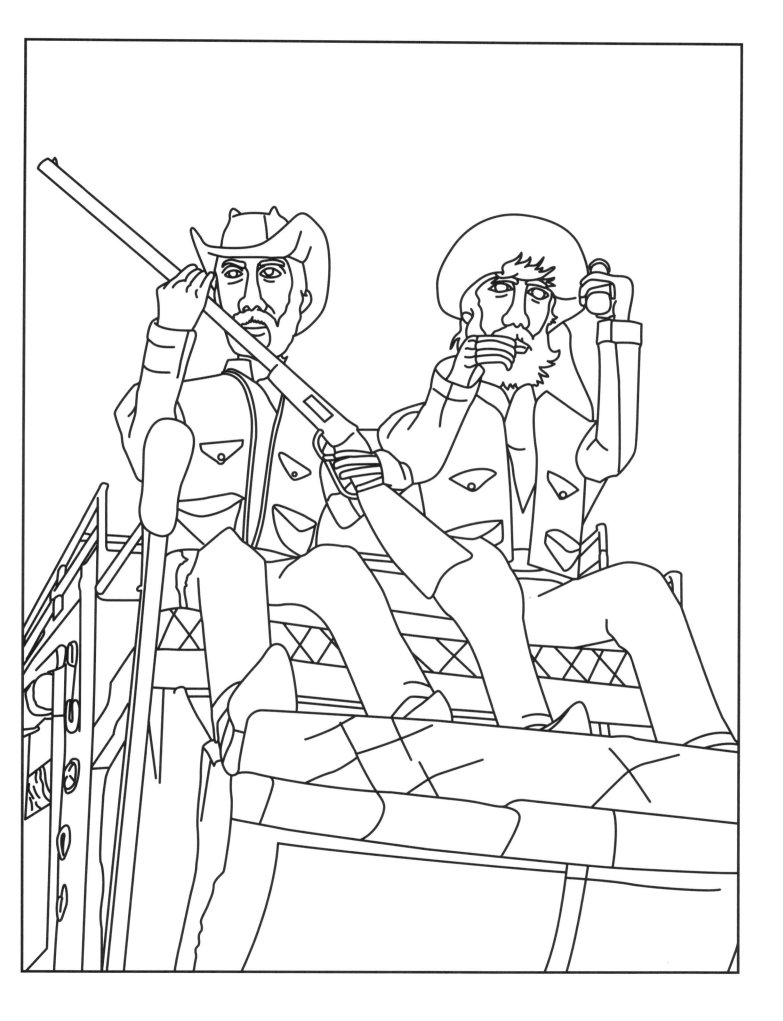

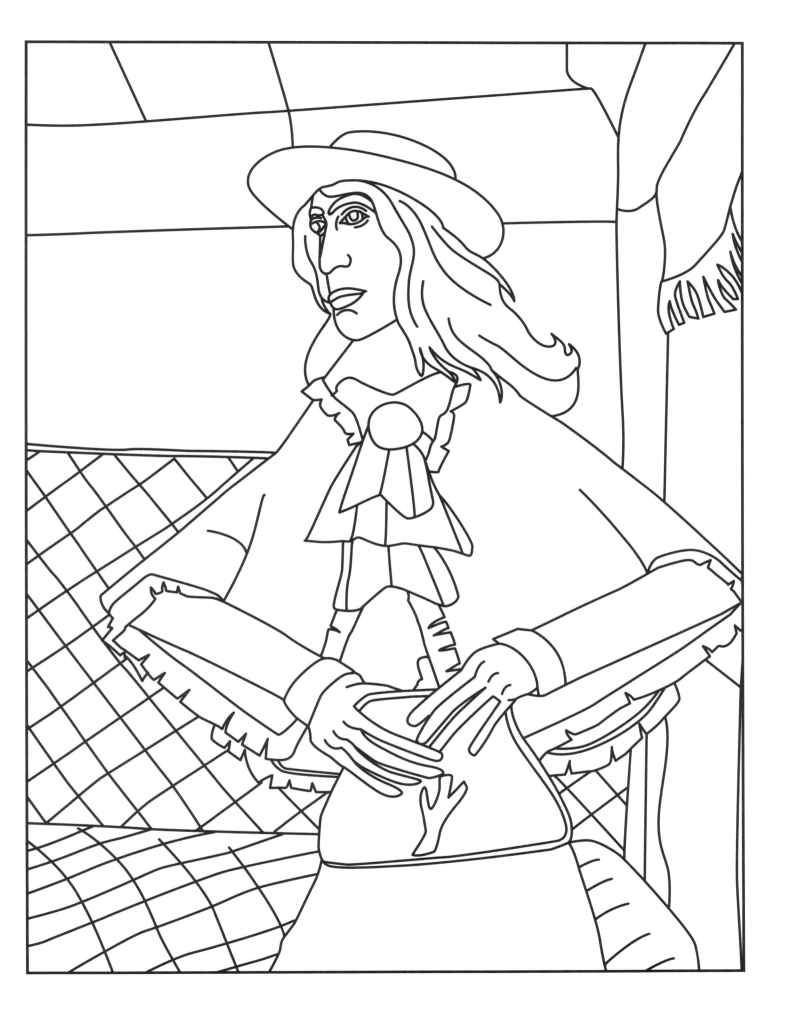

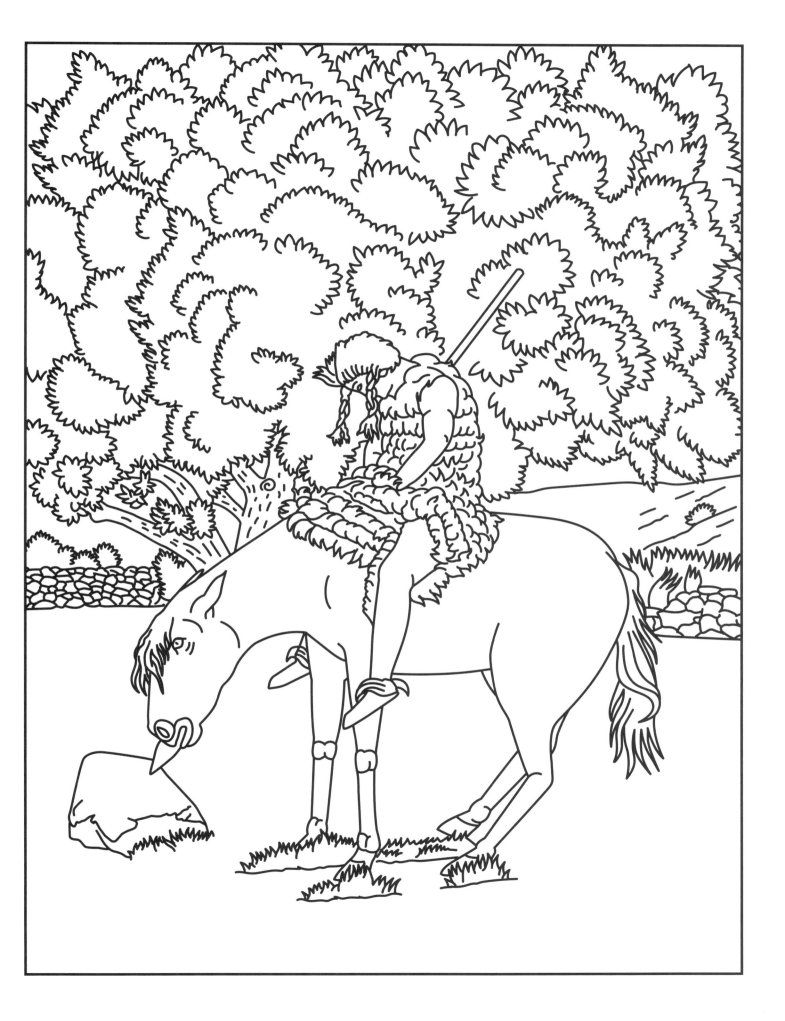

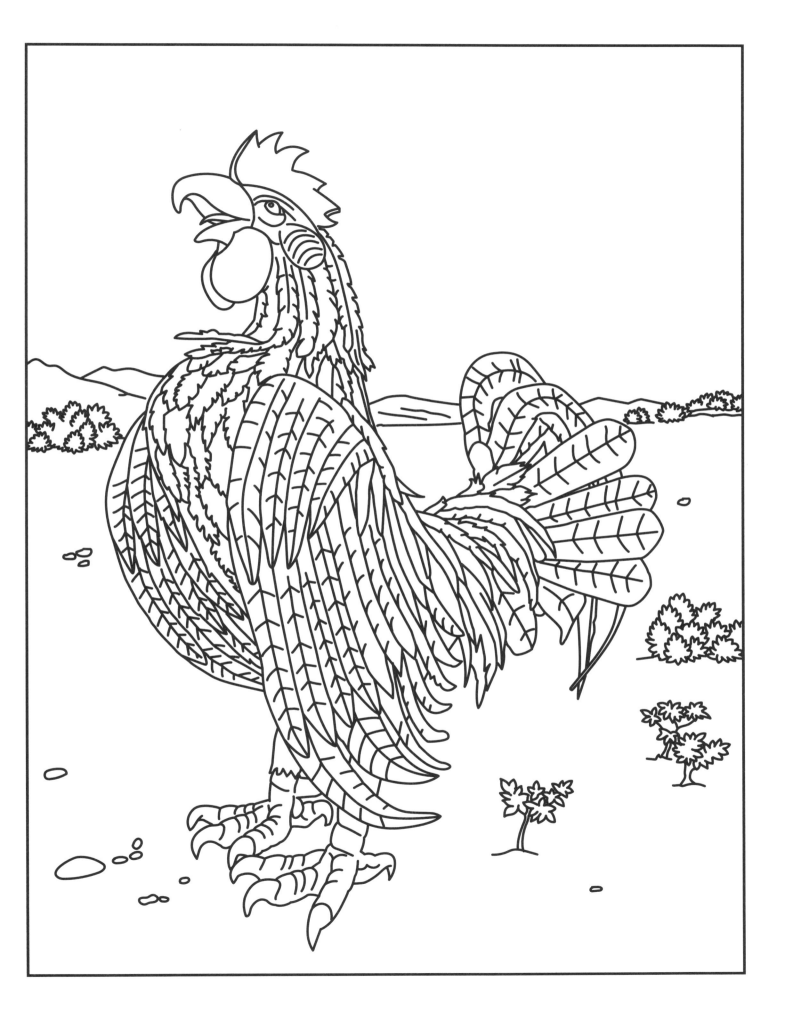

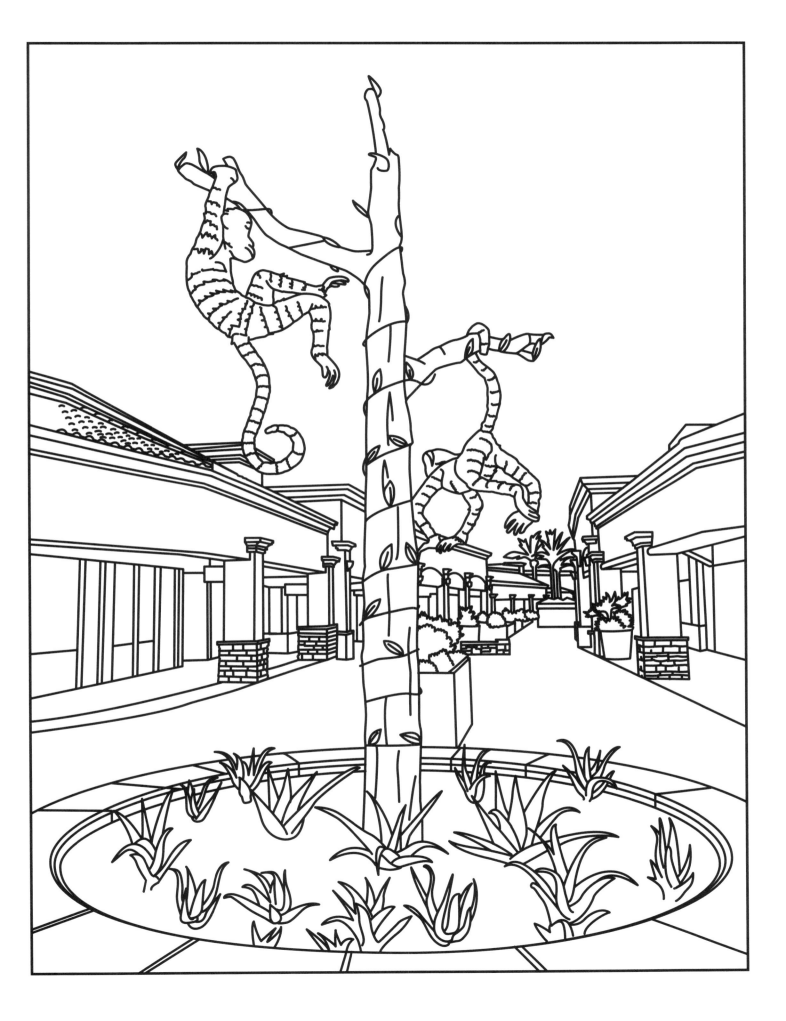

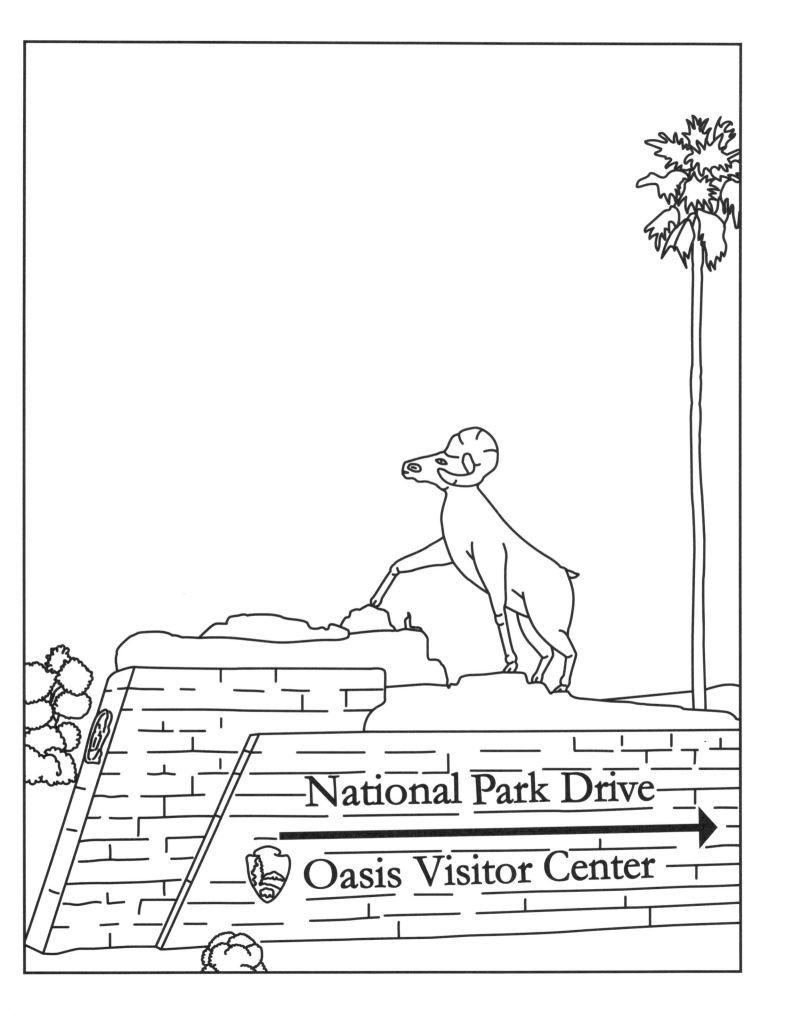

National Park Drive

Oasis Visitor Center

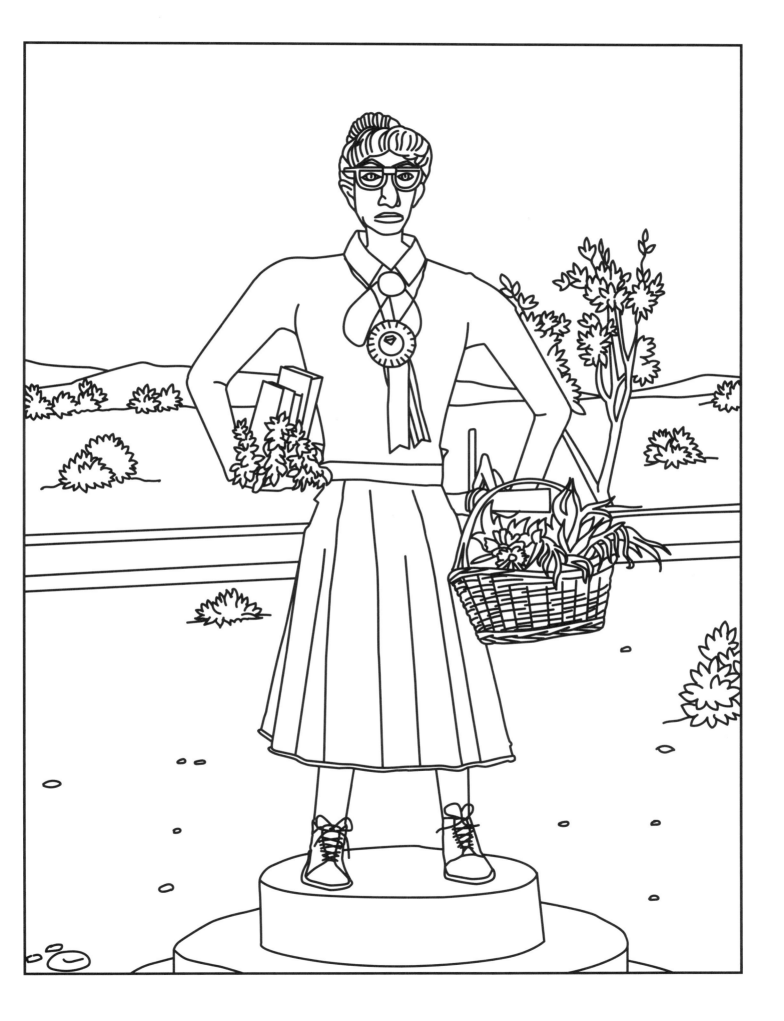

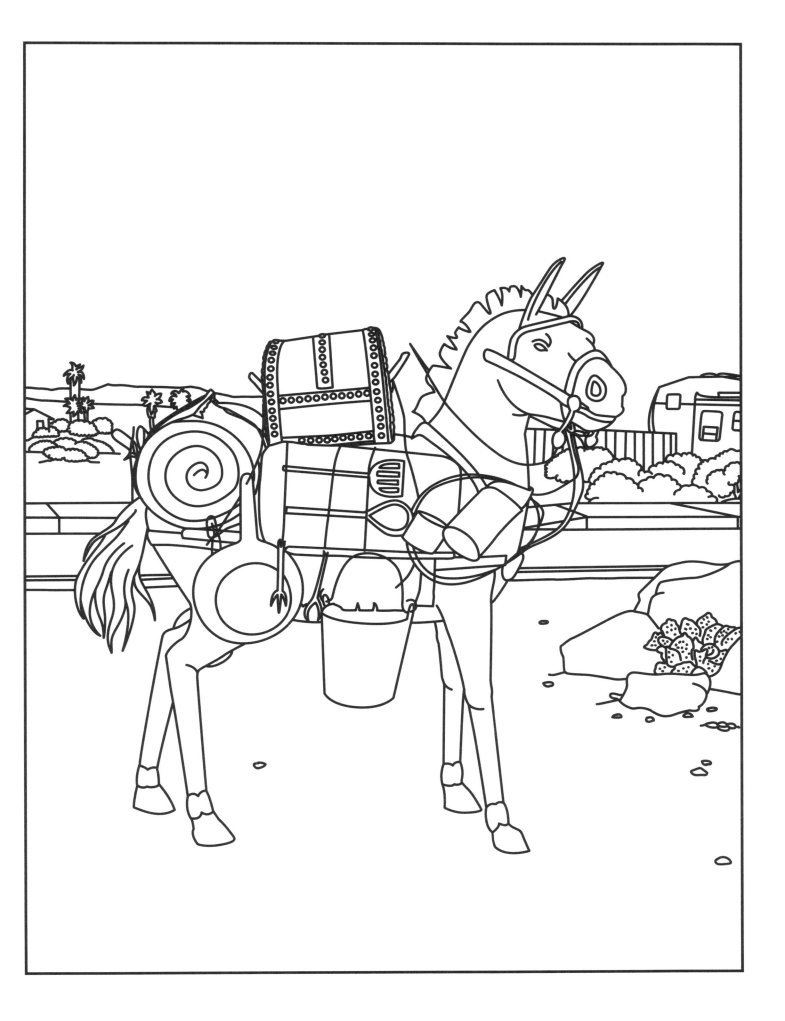

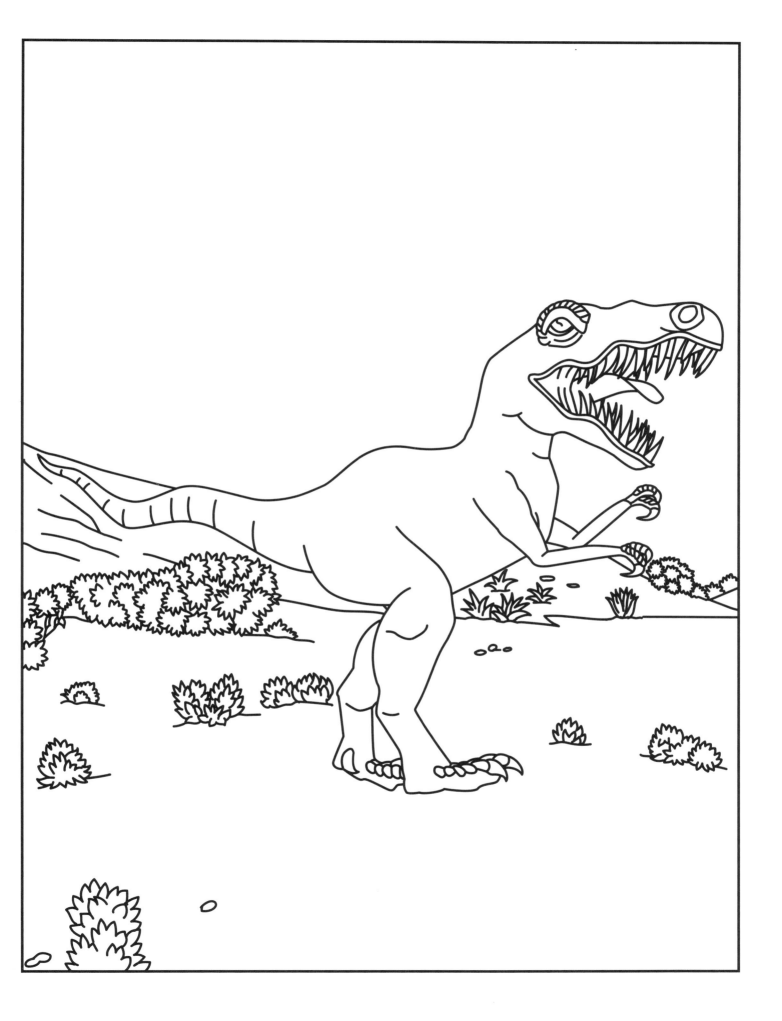

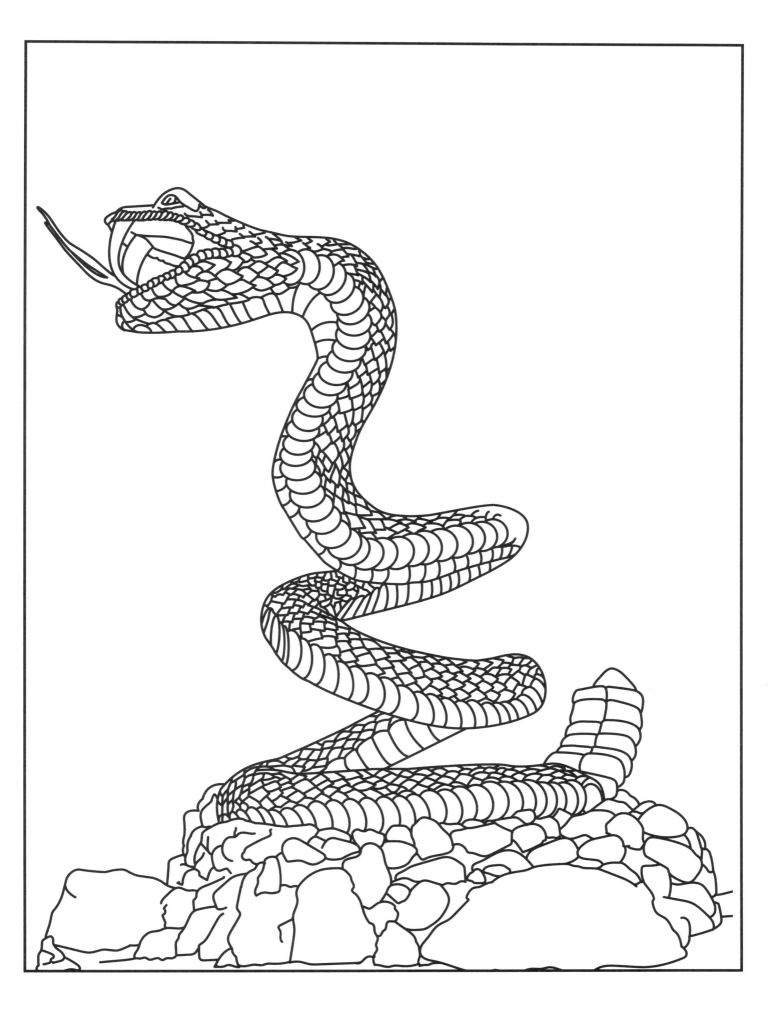

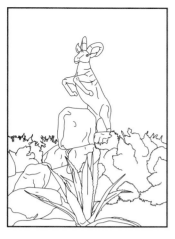

The desert bighorn sheep is the iconic animal of the California deserts and is symbolic of desert wilderness areas. Borrego is the Spanish word for sheep or lamb and is the reason why Anza-Borrego Desert State Park and Borrego Springs and Valley are so named. Desert bighorn sheep were first noted in Borrego Valley by Fr. Pedro Font, a diarists on the second Anza expedition in 1775-6. Metal sculptures of the desert bighorn are very popular in this desert area, especially as yard art in Borrego Valley.

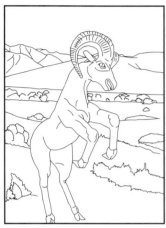

A real thrill for a desert visitor is to see a desert bighorn sheep, and one of the best places to chance upon one is Anza-Borrego Desert State Park, where 90 percent of California's designated wilderness is found. Wilderness is crucial to the survival of this endangered species. Bighorns are very elusive and difficult to see. Adult rams are very impressive with horns that grow almost to a full curl that can be more than 40 inches in length. The horns and skull of a mature ram can weigh up to 30 pounds. Ewes have shorter pointed horns.

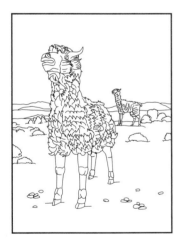

What makes the metal sculptures of Borrego Valley so special is that it brings back to life animals that once roamed this valley millions of years ago before it was a desert area. This ancestral llama known as a Hemiaucheniaspecies evolved in North America over 40 million years ago and later dispersed into South America where its descendants are still found. It is in the same family as camels. It was an open plains animal that fed on grasses. Members of this family are among the most common fossils found in the Anza-Borrego area.

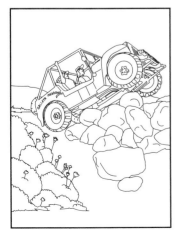

The iconic WWII military Jeep, manufactured by Willys-Overland, had its counterpart in a later-developed civlian Jeep (CJ) that first hit the market in 1945. The improved CJ-3A, manufactured between 1946-1953 and depicted in the metal sculpture, opened the desert to exploration and literally changed the way that people related to desert areas. It also created management nightmares with park preserves as rangers worked to control off-road use.

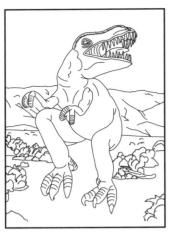

Borrego Valley resident and landowner Dennis Avery helped fund the publication of *Fossil Treasures of the Anza-Borrego Desert* (Sunbelt Publications, 2006) and later commissioned artist Ricardo Breceda to construct metal sculptures of Pleistocene animals that once roamed the Borrego Valley on his Galleta Meadows properties. Breceda wanted to construct dinosaurs also, and Avery finally relented. Although no dinosaurs ever roamed the Anza-Borrego area, it now has its own "Borrasic" park. This Tyrannosaurus rex is one of the more ferocious looking ones found in the Valley.

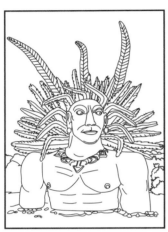

Dennis Avery wanted some of his sculptures to reflect the early history of Borrego Valley. He asked artist Ricardo Breceda to make a sculpture of an Indian that would represent either Sebastian Tarabal, a Cochimí Indian from Baja California who was a guide for the first Anza expedition to California in 1774, or Salvador Palma, chief of the Yuma Indians, who was instrumental in allowing the Spaniards to cross the Colorado River into California. The artist chose to represent Tarabal and/or Palma as an Aztec warrior.

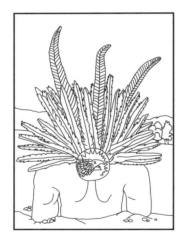

Ricardo Breceda's Aztec warrior shows great attention to detail. Extra care was taken in the construction of the feathers and adornments. Only the head was constructed because the Indian is situated looking north at Indian Head Ranch where Dennis Avery once lived. This sculpture is on Henderson Canyon Road across from the entrance gate to the ranch. Avery had the head and neck painted gold, including the earrings worn by the Indian. The Indian was one of several sculptures completed in 2008.

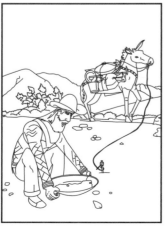

Prospecting and mining are very much a part of California history with many prospectors heading to the desert once the easy pickings were gone. Some of the prospectors of the Anza-Borrego area were looking for Pegleg Smith's lost gold or were looking for rich mineral-ladened veins associated with deposits of Julian schist. The prospector's mule carried everyting he needed including a pick, shovel, hammer, stakes, bedding, tent, tarps, bucket, water, food, pots and pans, rope, a rifle, and clothing. It was a lonely, hard life fed with the hopes of striking it rich.

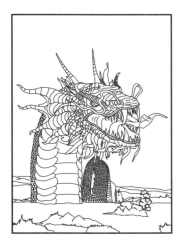

The serpent was the culmination of the move from depicting sculptures based on reality and history to pure fantasy. It was the beginning of the Chinese Year of the Dragon and Dennis Avery was inspired to commission his 129th sculpture in Borrego Valley based on his interest in the Great Serpent Mound in southern Ohio, his wife's Chinese school, and the desert. The 350-foot sea serpent dives under Borrego Springs Road, has a rattlesnake tail, and has the head of a dragon. It took three months to design, three months to install, and has over 1,000 scales.

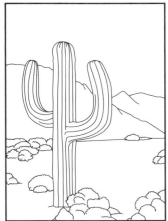

What is not normally seen in the Colorado Desert of California is the Sonoran Desert saguaro, commonly found to the east of the Colorado River in Arizona. But you will find one in Borrego Valley near the historical-themed sculptures commemorating the Anza expeditions to California. Anza's expeditions in the 1770s headed west out of Tubac, Arizona. The saguaro symbolizes a gathering point for those historic expeditions that would open California for Spanish settlement. The saguaro is a tree-like cactus species that can grow to be over 70 feet tall.

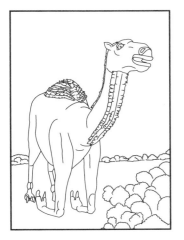

Camelids are the most diverse species found in Anza-Borrego's fossil record and the second most commonly found after horses. Camelids, which include llamas and camels, are distinguished by ipsilateral limb pairs with the fore and hind limbs on the same side moving together forward and back as the animal moves. They also have distinct foot bones with only two toes that allow them to thrive in open country and dryer climates. The largest Camelops species were 20 percent larger than today's dromedary camels.

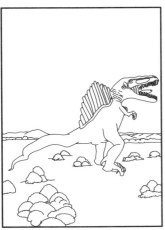

There are no fossil specimens found in the Anza-Borrego area from the Jurassic or Cretaceous periods. The various theropods and raptors found in "Borrasic" park are here for fun. The Spinosaurus is an example of a fossil specimen that is found in Egypt and Morocco. It had a 6-foot-long sail-like structure protruding from its back vertebrae. There are several Spinosaurus specimens grouped together in the southern part of Borrego Valley. These and other dinosaurs were installed here in 2009.

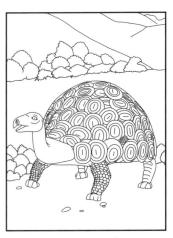

Today the only giant tortoises are found in the Aldabra Atoll in Seychelles and the Galapagos Islands in Ecuador, but during the Pleistocene, two species of tortoise roamed the Anza-Borrego desert. The largest measured almost 4-feet long, 3-feet wide, and 2-feet tall. These animals did not burrow and could only survive in a frost-free area where there were pools of water where they could cool themselves. They first appeared in the fossil record about 3-million years ago and continued through to about 1-million years ago. Look for these metal sculptures near the Indian Head Ranch gate on Henderson Canyoyn Road.

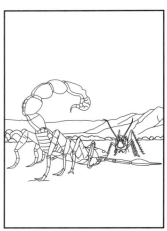

The scorpion and the grasshopper are the last metal sculptures installed (in 2012) on Galleta Meadows properties in Borrego Valley before the untimely death of Dennis Avery. Avery's estate continues to maintain Galleta Meadows following Avery's wish to keep the properties open for public enjoyment. Avery was inspired to create these sculptures when a scorpion was found in his desert home and Ricardo Breceda mentioned that the symbol of his home state of Durango, Mexico, is a scorpion. Scorpions eat grasshoppers. They are found east of the gomphotheres.

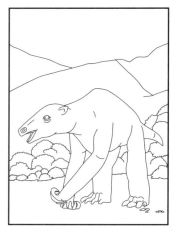

Shasta ground sloths are the smallest of the three sloth species that arrived in North America from South America about 2 million years ago when the climate was more arid. Shasta ground sloths were about the size of a small calf. They are in the order Xenarthra that includes armadillos, anteaters, and tree sloths. Animals in this order are unusual for their dentition that lacks enamel and their extra articulations between the vertebra of their lower back. These metal sculptures were moved from their original location to make room for the serpent.

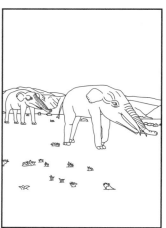

On the morning of April 10, 2008, Borrego Valley residents were surprised to see that gomphotheres had returned to the Anza-Borrego area after an absence of 3.7 million years. The family of gomphotheres were the first of 131 metal sculptures that were installed on scattered properties in Borrego Valley called Galleta Meadows owned by Borrego resident Dennis Avery of Avery label fame. Gomphotheres are elephant-like animals that were hippopotamus-size with short legs and four tusks that lived in marshy areas. The oldest fossil specimens are 9 million years old.

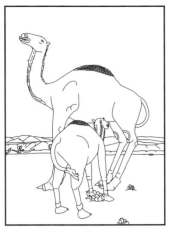

Near the gomphotheres are metal sculptures of members of the camel family. This large family first evolved in North America about 44 million years ago. Members of the camel family went extinct about 11,000 years ago in North America but are survived by modern llamas in South America and camels in Africa and Asia. There were at least eight species of camelids found in the Anza-Borrego area, which is the richest assemblage of nearly modern camelids known anywhere. Paleontologists have also found both camel and llama tracks that were formed in muddy deposits millions of years ago.

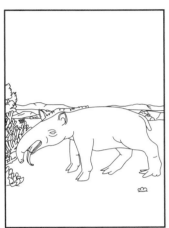

Members of the tapir family have had little change in their evolutionary history since they first appeared some 40 million years ago. Their closest relatives are the odd-toed ungulates (hooved animals) that include horses, rhinoceroses, zebras, and asses. Pleistocene tapirs came in two sizes—large and small. The largest was the Merriam tapir, which is the one represented in the metal sculptures. Modern tapirs are the largest land animal in South America, weighing up to 650 pounds. They look like a cross between a wild boar and an anteater. They are considered living fossils.

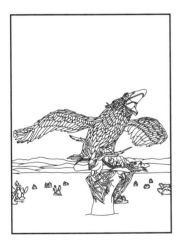

The are two metal sculptures of the huge Aiolornis incredibilisin Borrego Valley. One depicts the "incredible wind god bird" in a nest with its fledglings while the other shows it with prey in its talons. It was the largest flight-capable bird in North America, weighing about 50 pounds with a wingspan of 16-17 feet. The oldest specimens of this 4-foot tall condor-like bird date from about 1 million years ago. It was, however, not the only large fossil bird found in this desert area. There was also a species of the terror bird called Titanus that was a 6-foot tall flightless, carnivorous, ostrich-like bird that dated back to 3.5 million years ago.

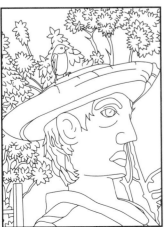

Part of the history of Borrego Valley includes migrant farm workers who harvested grapes until the United Farm Workers union called for a strike that lasted 5 years and was part of the national grape boycott from 1965-1970. Today there are barren fields that once held rows and rows of grapes, and in one of those fields, there are several metal sculptures depicting these farm workers harvesting grapes. A small finch rests on the top of one of sculptures. It's red breast complements the red rust hue of the sculpture.

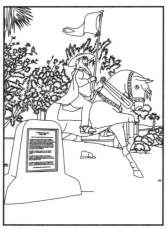

Spaniard Juan Bautista de Anza led two expeditions to California. The first expedition in 1774 is considered by some historians to be one of the most important events in California history as it opened the area for settlement and assured that the Spaniards and not the Russians could claim and hold this area for future expansion. The second expedition in 1775-6 brought families, horses, and cattle to settle in the San Francisco Bay area. It is fitting that California's largest state park should be named after this Spaniard. A metal sculpture of Anza is found in front of the Borrego Springs Chamber of Commerce.

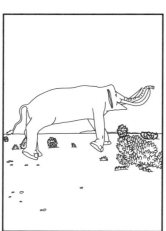

Mammoths are medium to large-size elephants that evolved in southern and eastern Africa about 4 million years ago and subsequently spread to Europe, Asia, and North America. Four different species crossed the Bering land bridge. Only two of the species are found in the fossil record of the Colorado Desert. The southern mammoth was a medium-sized elephant that was here at least 1.4 million years ago. The Columbian mammoth was the largest North American mammoth. Skeletal remains found in the Anza-Borrego area are 1.1 million years old. Metal sculptures of the Columbian mammoth are found along Borrego Springs Road in southern Borrego Valley.

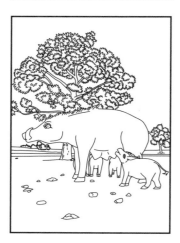

Peccaries are relatives of Old World pigs that once roamed over North America. Peccaries are even-toed ungulates or hoofed animals that include llamas, camels, deer, sheep, cattle, giraffes, and pronghorns. Peccaries were like their living pig relatives who are gregarious and live and hunt in packs and eat a variety of things that include leaves, seeds, roots, fruit, worms, larvae, small vertebrates, and eggs. Their bodies were larger than modern peccaries now found in Central Southwest deserts of the US into South America. In the Anza-Borrego area they date from 3 million to 1.7 million years ago.

Sculptures of sabretooth cats may be found in a variety of poses in Borrego Valley. Some are reclining, some are chasing or catching prey, while others are fighting. The gracile sabretooth cat (Smilodon gracilis) is the most commonly recovered felid fossil in the Anza-Borrego area. Anza-Borrego holds the only fossil record for this species in western North America. The gracile sabretooth cat is smaller than Smilodon fatalis—California's state fossil. It hunted by laying in ambush rather than chasing down its prey.

Ricardo Breceda is the "Accidental Artist" who never intended to make metal sculptures. He was educated as a teacher in Mexico and came to the US to earn a higher income. An accident prevented him from returning to his construction work, and he began selling western boots, which he sometimes traded for things, such as a welding machine. His 5-year-old daughter Liana told him that she wanted him to make her a life-size dinosaur for Christmas. Not wanting to disappoint his daughter, he said he would, and so began his career as a metal sculpture artist. Breceda enjoys making ferocious-looking dinosaurs, such as this spinosaurus.

Like the other dinosaurs in "Borrasic" park, no fossils of the Utahraptor are found in the Anza-Borrego area. This was a very large intelligent raptor that stood 6-feet tall. This bird-like dinosaur may have hunted in packs. It would have towered over the 2- to 3-foot tall Velociraptorsthat are also represented in metal sculptures in the Borrego Valley. As its name indicates, the Utahraptor was first found in Utah. In contrast, Velociraptorshave not been found in North America. Fossils of this bird-like raptor come from Mongolia.

Ricardo Breceda's metal sculptures may also be seen in the small community of Ocotillo Wells at the Desert Ironwood Resort near the headquarters for Ocotillo Wells State Vehicular Recreation Area off highway 78. There is quite a variety of sculptures found there that include giraffes, stags, donkeys, a prospector, mules, saguaros, bighorn sheep, horses, raptors, dolphins, elephants, tortoises, peccaries, a napping mexican with a large sombrero, a coyote, and even a small brontosaurus.

Dennis Avery was not the only major patron for Ricardo Breceda. The doctor who founded and owns the animal microchip device called AVID (American Veterinarian Identification Device) asked Breceda to construct several different animals around his Norco veterinary business that includes monkeys, elephants, ostriches, giraffes, an African rhinoceros, zebras, oryxes, and more. The menagerie can be seen in the parking area for the medical complex. Some of the sculptures can also be seen from I-15 when passing through Norco.

As Ricardo Breceda gained more experience working with sheet metal, he also became more creative and paid more attention to detail. As a young man he liked to visit museums and spent his younger years on ranch lands owned by his family in Durango, Mexico. He is particularly good at depicting animals in a natural stance. That is one of the reasons that the Animal and Bird Veterinary Center in Norco commissioned him to construct metal sculptures in their parking area. Here a baby elephant tugs on its mother's tail.

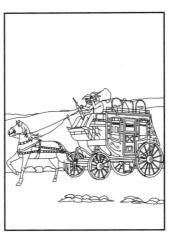

The Butterfield Overland Mail operated from 1857 to 1861 with many stations between St. Louis and San Francisco. One of the major stations in the Anza-Borrego area was Vallecito, which is now a county park where visitors may tour the old station building. The stagecoach carried mail and passengers. Artist Ricardo Breceda built a replica of the Wells Fargo stagecoach with passengers that he entered in the 2011 annual Borrego Springs Desert Festival parade. Today the stagecoach may be seen in Aguanga, California, just off highway 79, not too far from the original Butterfield route.

Stagecoaches were often harrassed by outlaws looking for valuable cargo. A guard rode shotgun next to the driver who held reins in one hand and possibly a whip in the other hand. Passengers were encouraged to carry their own guns if needed. It took about 25 days to travel by stagecoach from St. Louis to San Francisco on the Butterfield Overland Mail—a distance of about 2,800 miles. Stagecoaches traveled at breakneck speeds, 24-hour a day, stopping at stations to pick up a fresh team of horses. The southern route was changed in 1861 at the outbreak of the Civil War.

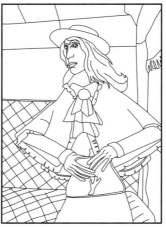

Travel by stagecoach was a major challenge for passengers. Waterman L. Ormsby, a reporter for the *New York Herald* and the first through passenger on the Butterfield Overland Mail from St. Louis to San Francisco wrote, "I know what hell is like. I've just had 24 days of it." The stage rolled 24-hours a day except for breaks at stations to change horses. Passenger learned to sleep while bumping along the roads and considered themselves lucky if they had up to three baths during the whole trip. The fare was $200.

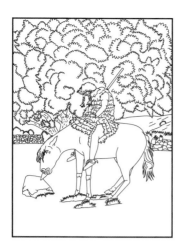

Ricardo Breceda was inspired by James Earle Fraser's bronze sculpture of "End of the Trail" to create his own version of this famous sculpture. Fraser first modeled it in 1894. The sculpture was based on Fraser's experiences growing up in the Dakota Territory. In 1915 he made a large plaster version of his work that he entered in the Panama-Pacific International Exhibition in San Francisco and won a gold medal. It is an iconic symbol that has come to mean resilience and strength to Native Americans rather than defeat. It can be seen in Aguanga along Highway 79.

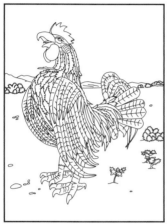

In 2017 Ricardo Breceda focused on creating a large detailed rooster for the Chinese zodiac collection found at the Desert Hills Premium Outlet in Cabazon. Eventually all animals of the Chinese zodiac will found there. As he has done with other creations, he has made copies that are on display at his Aguanga property, his first permanent home. Breceda began his journey as an artist in Perris and later moved to Vail Lake. He is now located in Aguanga, where he owns the 20 acres just off highway 79.

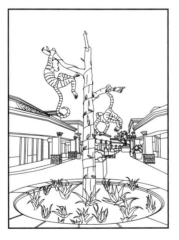

Desert Hills Premium Outlet in Cabazon commissioned Ricardo Breceda to create a different animal sculpture each year for the Chinese Zodiac. To date they have displayed a horse (2014), sheep (2015), monkey (2016), and rooster (2017) with others to follow in the years ahead. In 2018 Breceda will install a dog; 2019 will be a pig; 2020 will be a rat; 2021 will be an ox; 2022 will be a tiger; 2023 will be a rabbit; 2024 will be a dragon; and 2025 will be a snake. Recall that Dennis Avery's serpent dragon in Borrego Valley was commissioned to celebrate the Year of the Dragon.

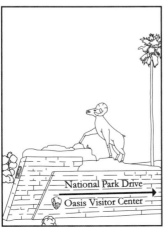

Desert bighorn sheep (Ovis canadensis Nelsonii) range beyond eastern and southern California to southern Nevada and Utah and northern Arizona. So it makes perfect sense that Joshua Tree National Park has a desert bighorn greeting visitors and directing them to the park entrance south of Twentynine Palms, California. Bighorns are an iconic symbol for the Palm Springs area. Ricardo Breceda also has other sculptures near the park entrance that include a ewe and lamb, a prospector and mule, and early pioneers near the Old Schoolhouse Museum.

The Old Schoolhouse Museum near the entrance to Joshua Tree National Park in Twentynine Palms is the home of the Twentynine Palms Historical Society. The society owns and operates the museum, which is the oldest public building in the Morongo Basin. One of the rooms in the museum replicates a 1920s-era school room. The society co-sponsors with the Joshua Tree Desert Institute an Old House Lecture Series held September-June. Ricardo Breceda was commissioned by the society to construct metal sculptures on the museum grounds that depict a school marm and local pioneers.

Mules were more commonly used than horses by early-day prospectors as they made better pack animals and were preferred for pulling wagons of pioneers. They will more easily follow a string of pack animals, are more sure-footed, can endure heat better than horses, live longer and eat less, and can carry more weight. A mule is the result of breeding a male donkey and a female horse. They are normally infertile and do not breed. Mules are stronger than donkeys and are more dependable on a trail as they spook less easily. A 900-pound mule can carry up to 200 pounds of gear all day without tiring excessively.

As more and more people have become familiar with Ricardo Breceda's sculptures,—largely due to the extensive display and publicity about the Borrego Valley sculptures that Dennis Avery commissioned—interest in his metal work has spread with customers as far away as Australia and Canada. His works are found in many locations in San Diego and Riverside counties, including businesses, private homes, parks, shopping centers, and even cities. The City of La Quinta near Palm Springs purchased bighorn sheep and a Tyrannosaurus rex.

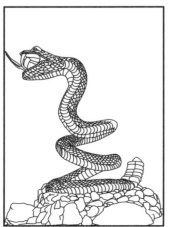

In 2013, the town of Jacumba commissioned Ricardo Breceda to make a giant 1,200-pound metallic rattlesnake for its community park, made from 26-gauge sheet metal. Some of the residents in town also wanted sculptures on their own property. A visit to Jacumba will lead to a variety of sculptures that include a pair of battling desert bighorn sheep, a stag, a dragon at a replica of a Chinese castle, and other sculptures scattered around the small town. A map at the community park shows the location of some of the sculptures.

Sunbelt Publications Recommended Reading

Bighorns Don't Honk Stephen Lester & Nathaniel Jensen
A bighorn sheep saga for children from nine to ninety, bighorns can climb almost anything. They can leap from ledge to ledge and only need two inches to land. They run fast, swim and have some of the best eyes in the animal kingdom. Their fights sound like thunder. The book includes important facts about this American West icon with fun-to-read rollicking verse and hilarious illustrations.

Borrego Springs Sculpture Guide, 2nd edition Diana Lindsay
This handy booklet contains new updated information about the incredible life-size metal sculptures of Borrego Valley, CA.

Coast to Cactus: The Canyoneer Trail Guide to San Diego Outdoors Diana Lindsay, Mgr. Ed.
Take a hike with a naturalist—a virtual Canyoneer to know and appreciate San Diego County's biodiversity while exploring it firsthand on any one of over 250 trail guides, written by the San Diego Natural History Museum Canyoneers.

Fossil Treasures of the Anza-Borrego Desert George T. Jefferson, Lowell Lindsay, Eds.
A richly illustrated volume by 23 leading scientists and specialists that reveals North America's most continuous fossil record for the last 7 million years. Included in this volume are camels, giant sloths, mammoths, and sabretooth cats.

Geology and Lore of the Northern Anza-Borrego Desert Region Monte L. Murbach & Charles E. Houser, Eds.
"The Lows to Highs of Anza-Borrego Desert State Park" field trip produced studies of the geology, mines, groundwater, geologic structure, faulting, and paleontology-inspired "Sky Art" metal sculptures of Borrego Valley. Vistas from Fonts Point and the Salton Sea Overlook range from deep basin "lows" up Banner Grade to the "highs" of mile-high mountains.

My Ancestors' Village Roberta Labastida
This charming story, told from the viewpoint of a young Indian from the Kumeyaay (Kumiai) nation, describes the traditional way a family lived.

Sky Art Metal Sculptures Map, 2nd edition Diana Lindsay
A laminated guide to the 131 stunning metal sculptures in Borrego Valley, CA.

Sunbelt produces and distributes publications about "Adventures in the Natural History and Cultural Heritage of the Californias" including guidebooks, regional references, and stories that celebrate the land and its people.